Seasons

The Watercolors of Helen Murdock-Prep

For my parents, with love.
(Thanks for my first set of Doodlers!)

With special thanks to Molly Prep,
for without her creative and technological assistance this book would not exist.

Seasons, The Watercolors of Helen Murdock-Prep copyright 2019
Helen Murdock-Prep
Illustrations copyright 2019 Helen Murdock-Prep
Formatting and Layout: Molly Prep

All rights reserved. Printed in the United States of America.
No part of this book may be used or reproduced in any manner
whatsoever without written permission, except in the case of reprints
in the context of reviews.

www.instagram.com/helen.ink
www.redbubble.com/people/helenink
www.etsy.com/shop/HelensCalligraphy
Also by Helen Murdock-Prep:
High Drama: A Novel
Lettering Life: Calligraphic Inspirations
Rainy Day Friend

ISBN: 978-0-578-60751-1
Published by Moheke Press

How my art is born

I have a very noisy, social, collaborative part of my life; but to figure out watercolor, I leave that behind. I become quiet—like I'm attending a Silent University. In this state, my inner life has time to ponder and I can naturally feel my way to imaginative solutions. Sometimes, when I'm walking down the block, folding laundry or stirring soup, my Silent University is in full session; my mind humming along at full creative throttle. To move those images shuffling around in my head, I grab a round brush and some Arches paper and begin.

I'm a newbie at watercolor and one of my favorite things about it is watching how the paints behave as they are released onto the paper. The colors bleed and blend as they flow across the page, and I think, "I'm not painting—the paints are!"

Sometimes I work from photos when I paint my watercolors, a new experience for me. I am training my eyes to paint the shadows I see that comprise the shapes of my subjects—a more technical way to work than I'm used to. When I illustrate, I am almost entirely working from inside my brain—not looking at a subject at all. I use my imagination to visualize what I want to draw. It's a freer and more organic way to express myself, but I am also enjoying learning this disciplined way, as well.

> "I am always doing what I cannot do yet in order to learn how to do it."
> -Vincent Van Gogh

The creative process in a nutshell! We have to start somewhere. As an artist, I have hunches; curiosity compelling me to try out notions, but ultimately, jumping in and splashing water around on paper is how I actually learn this art form. It is in the playing that the unknown becomes known. I am ever-learning and uncertain always.

Thank you for watching as I find my way.

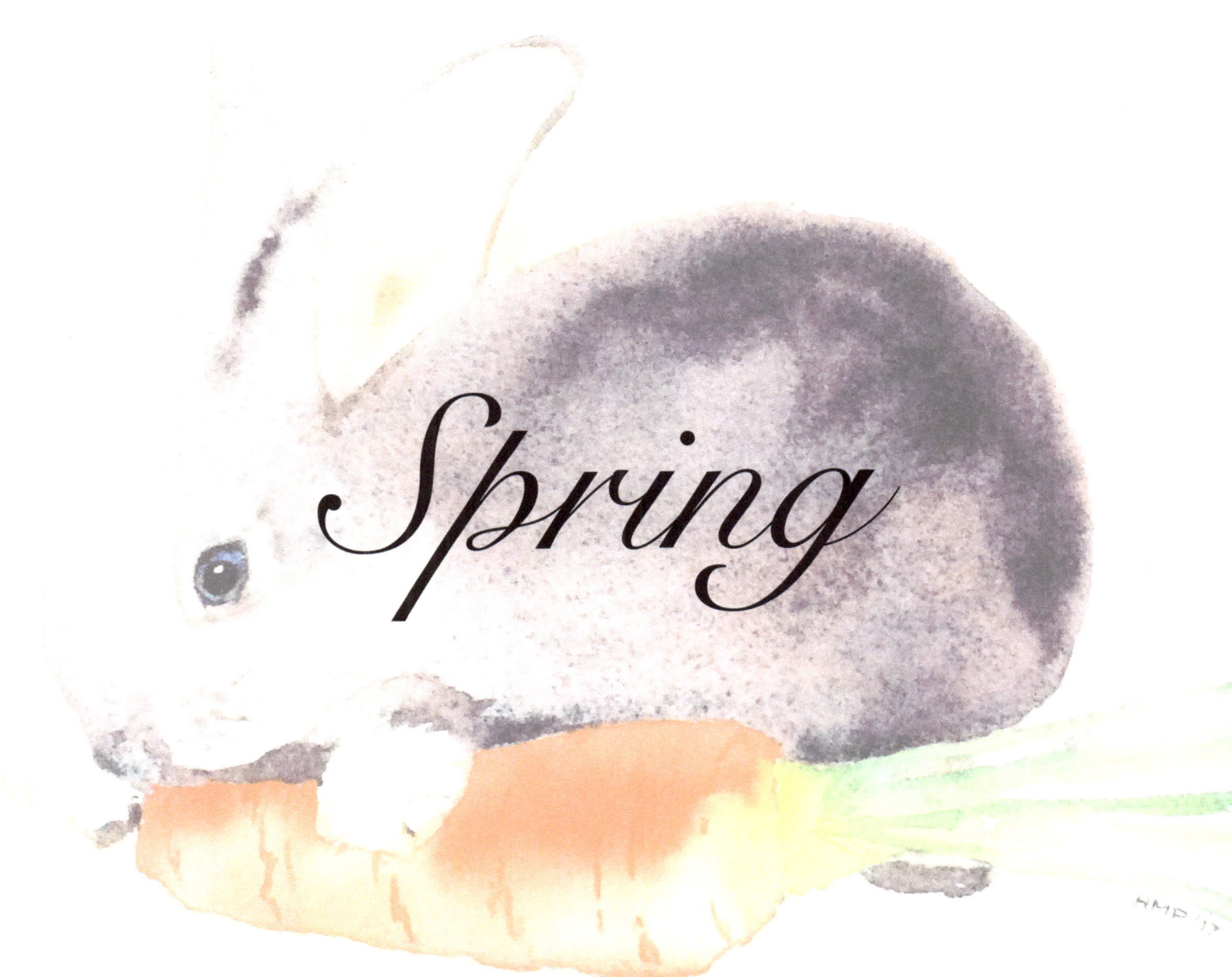

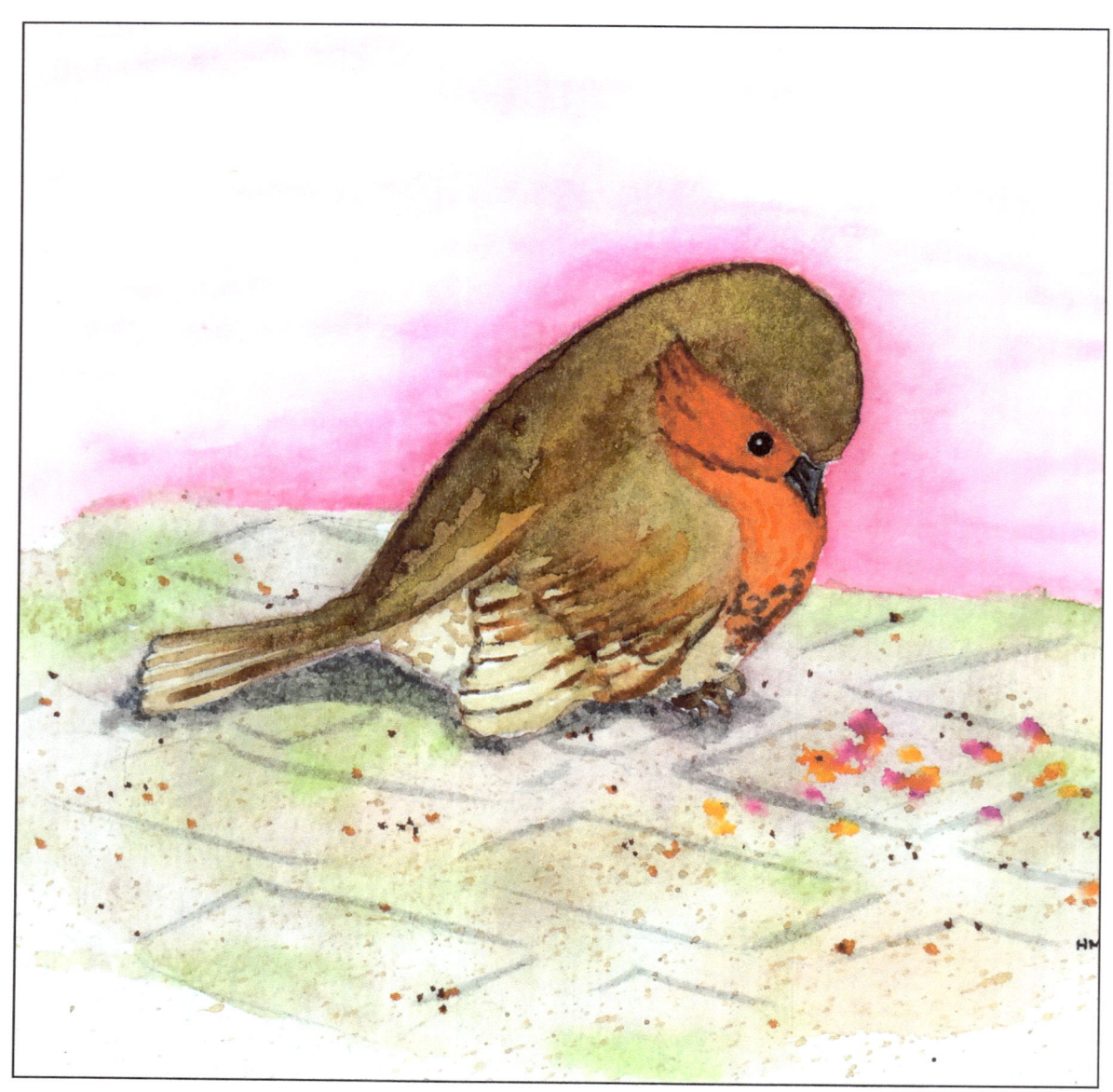

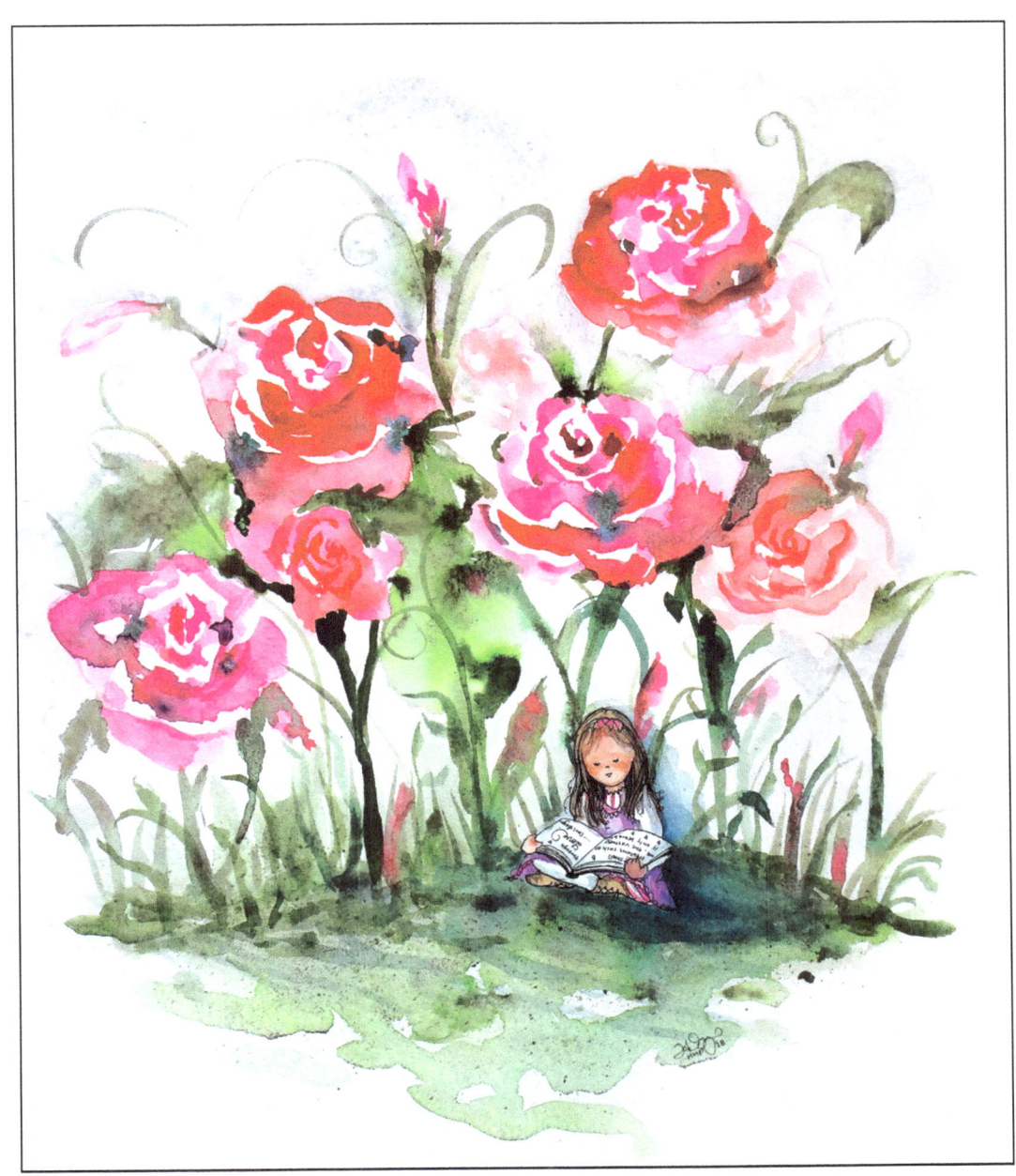

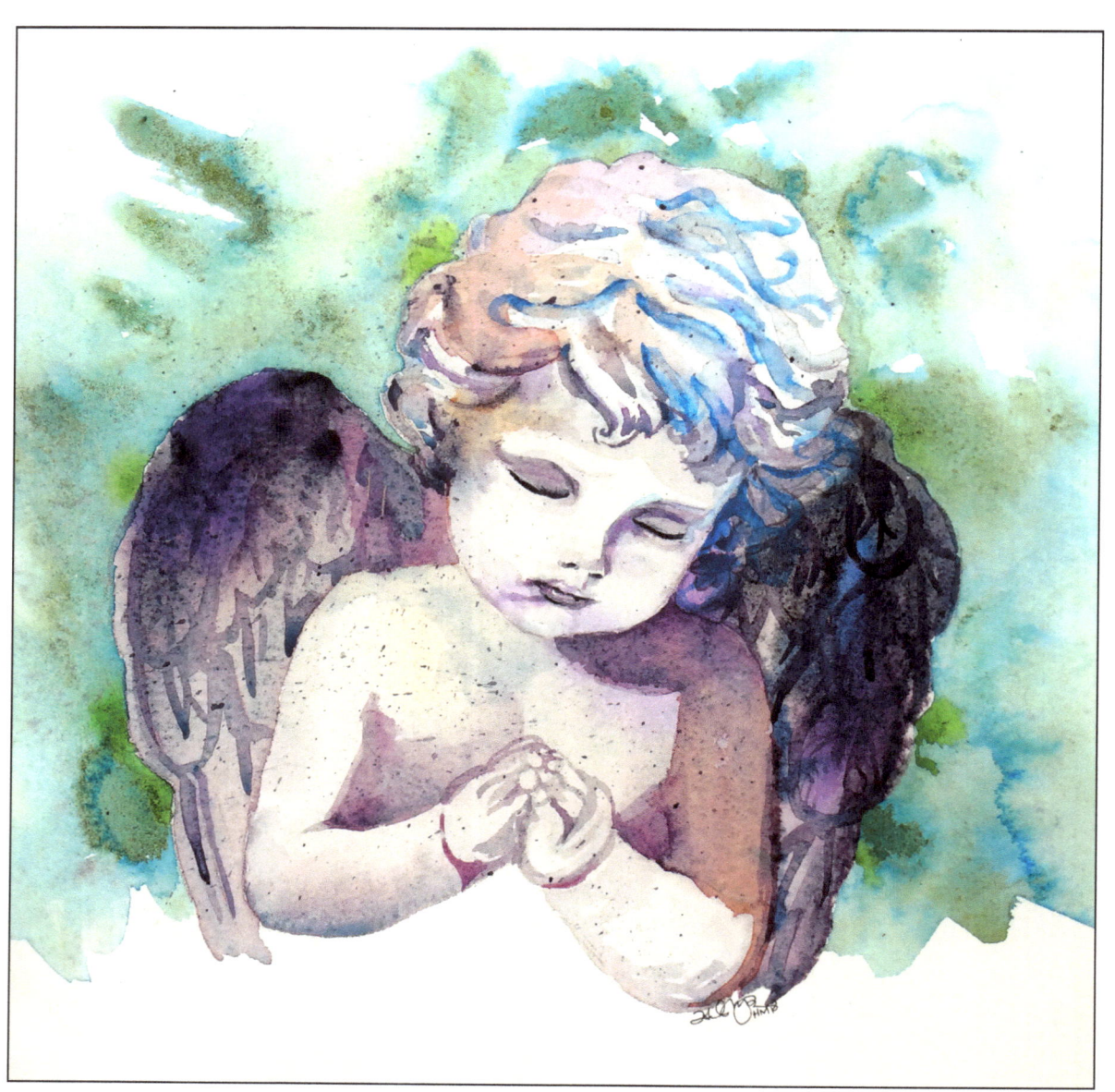

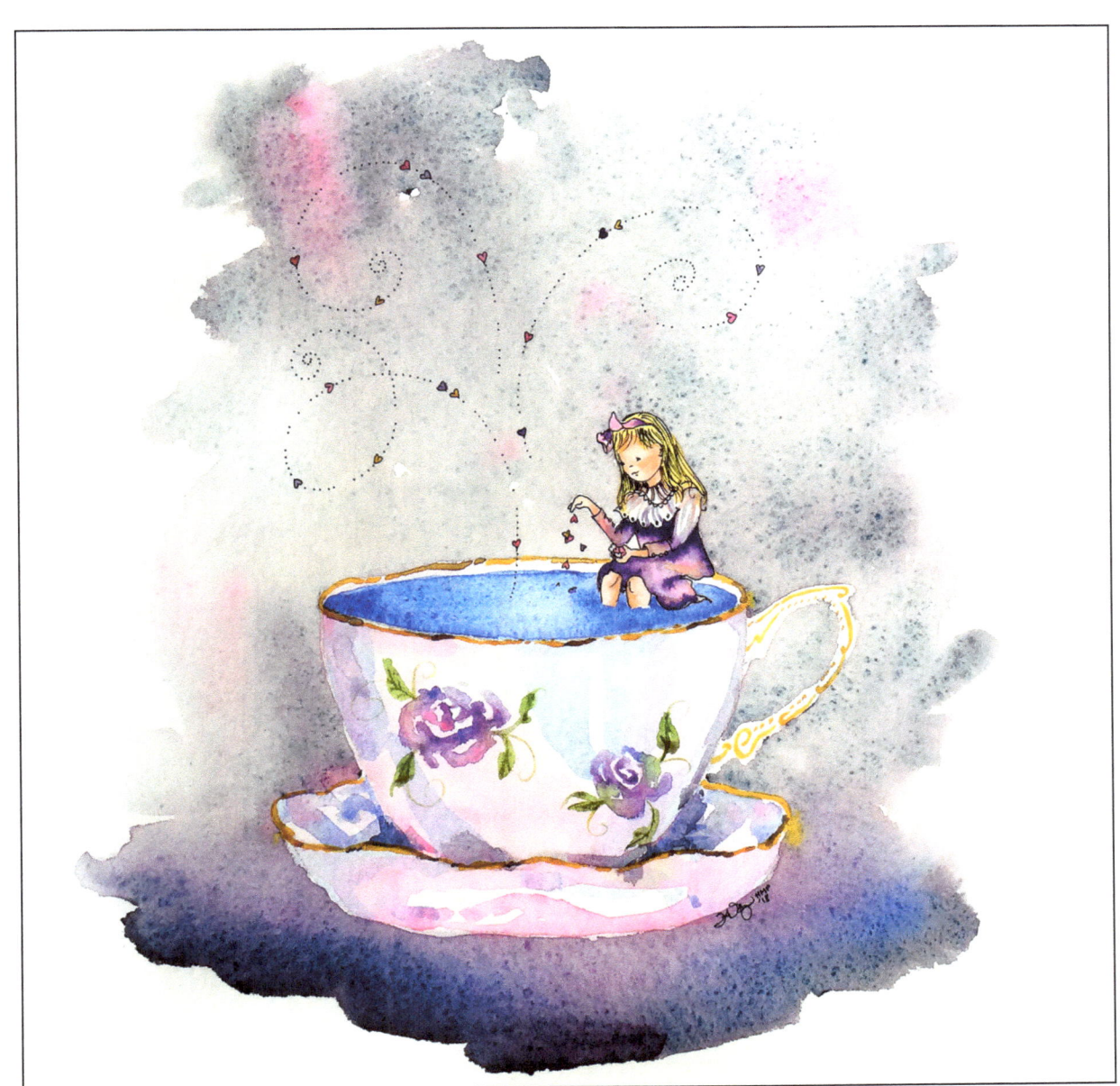

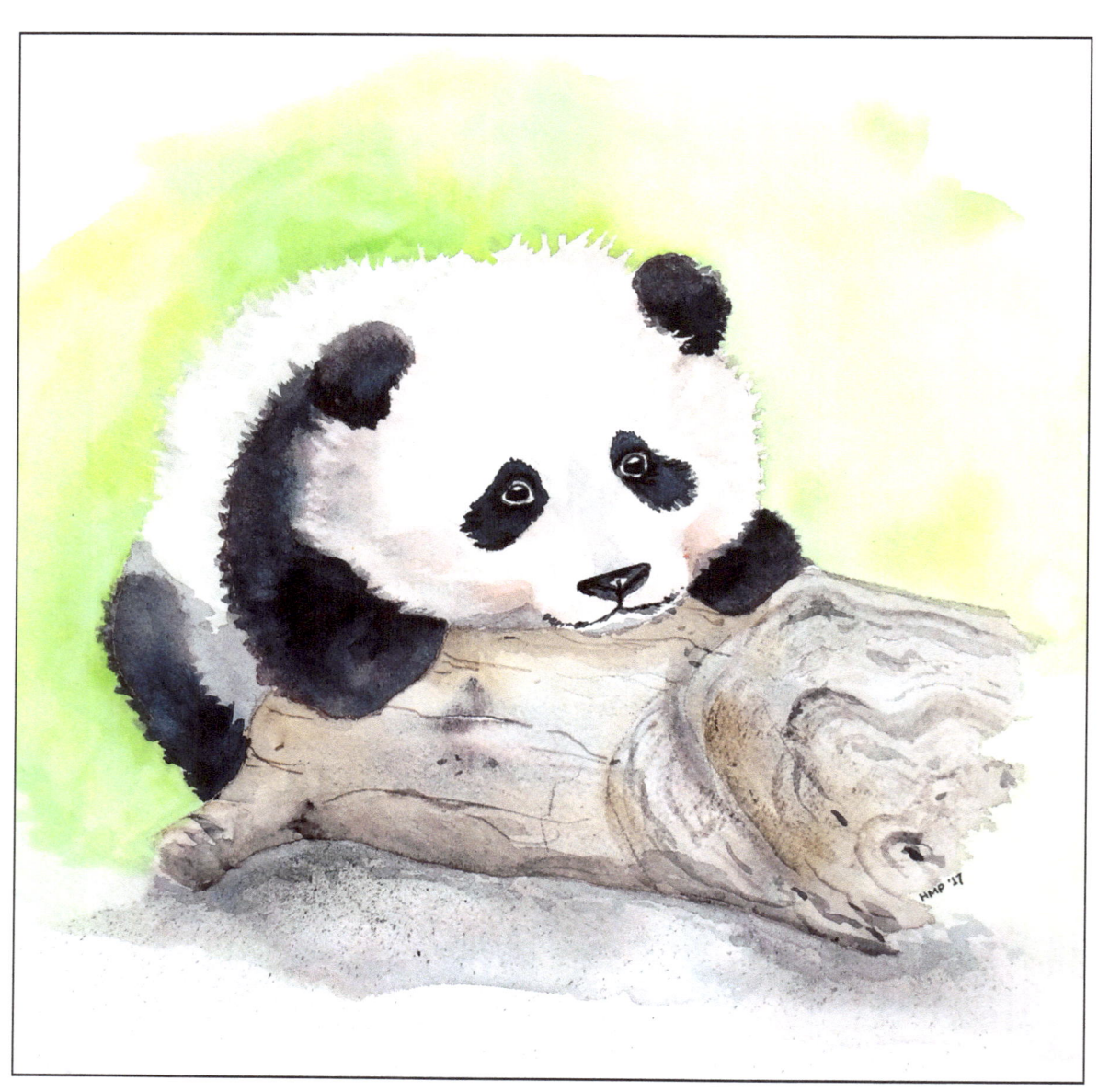

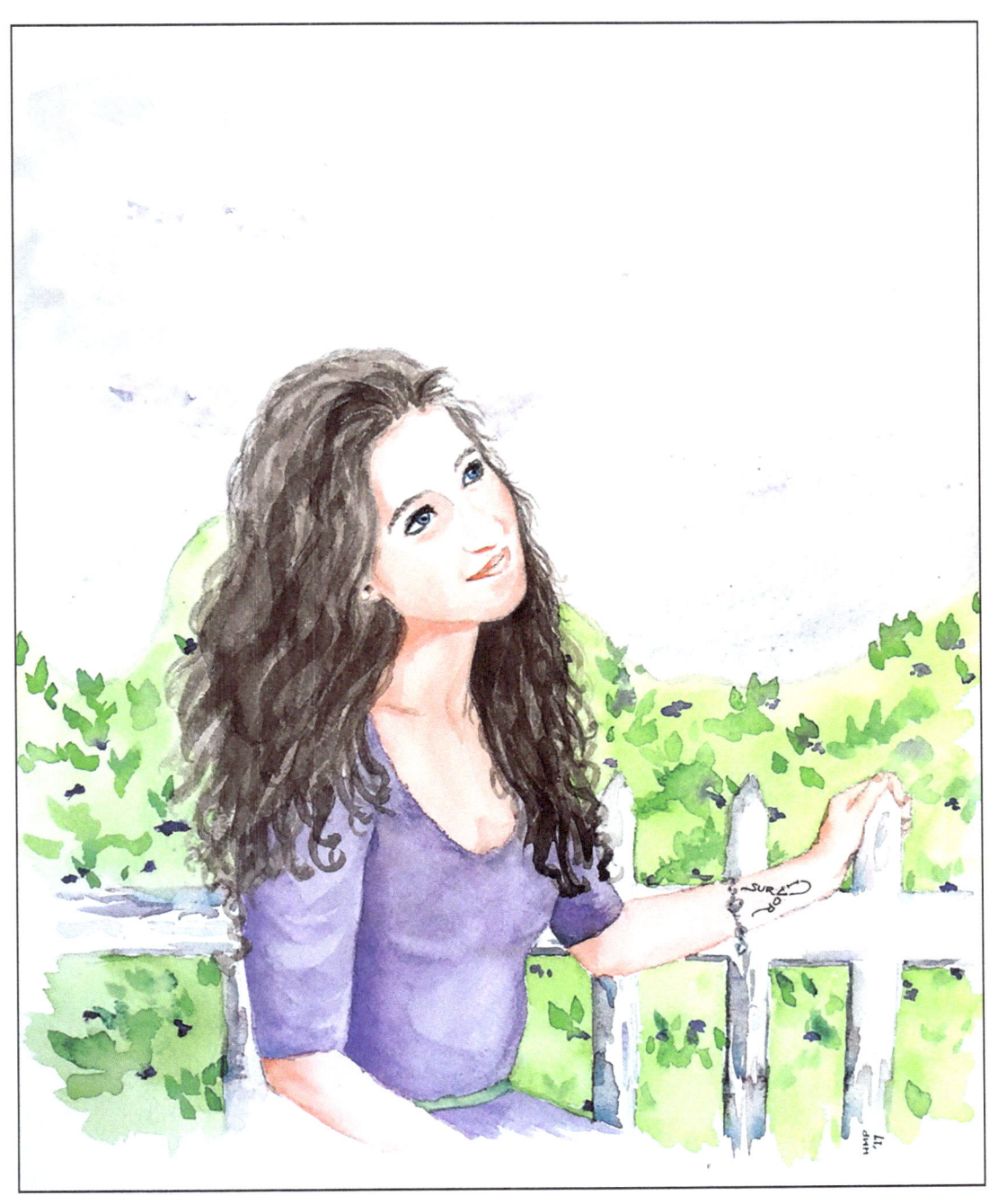

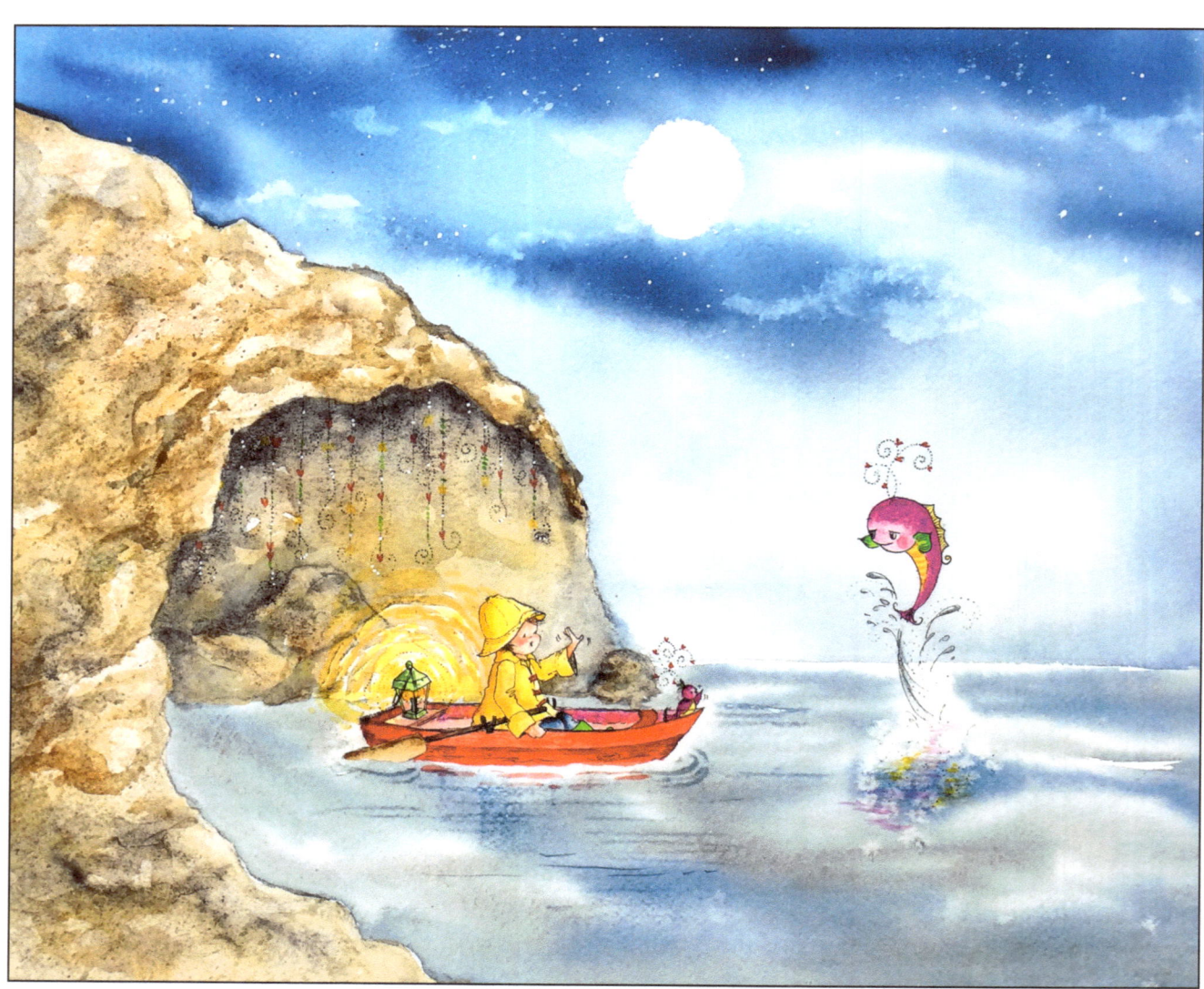

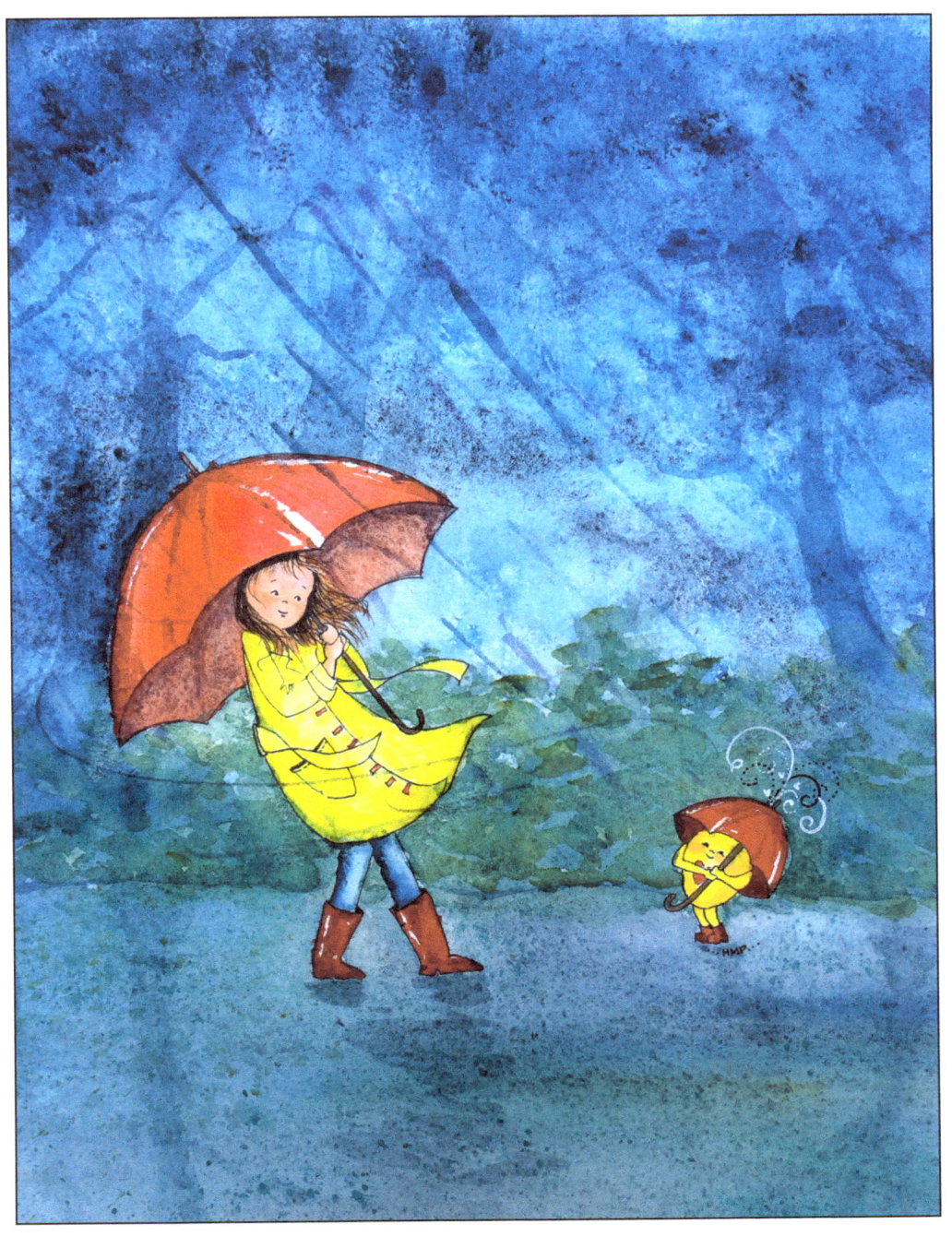

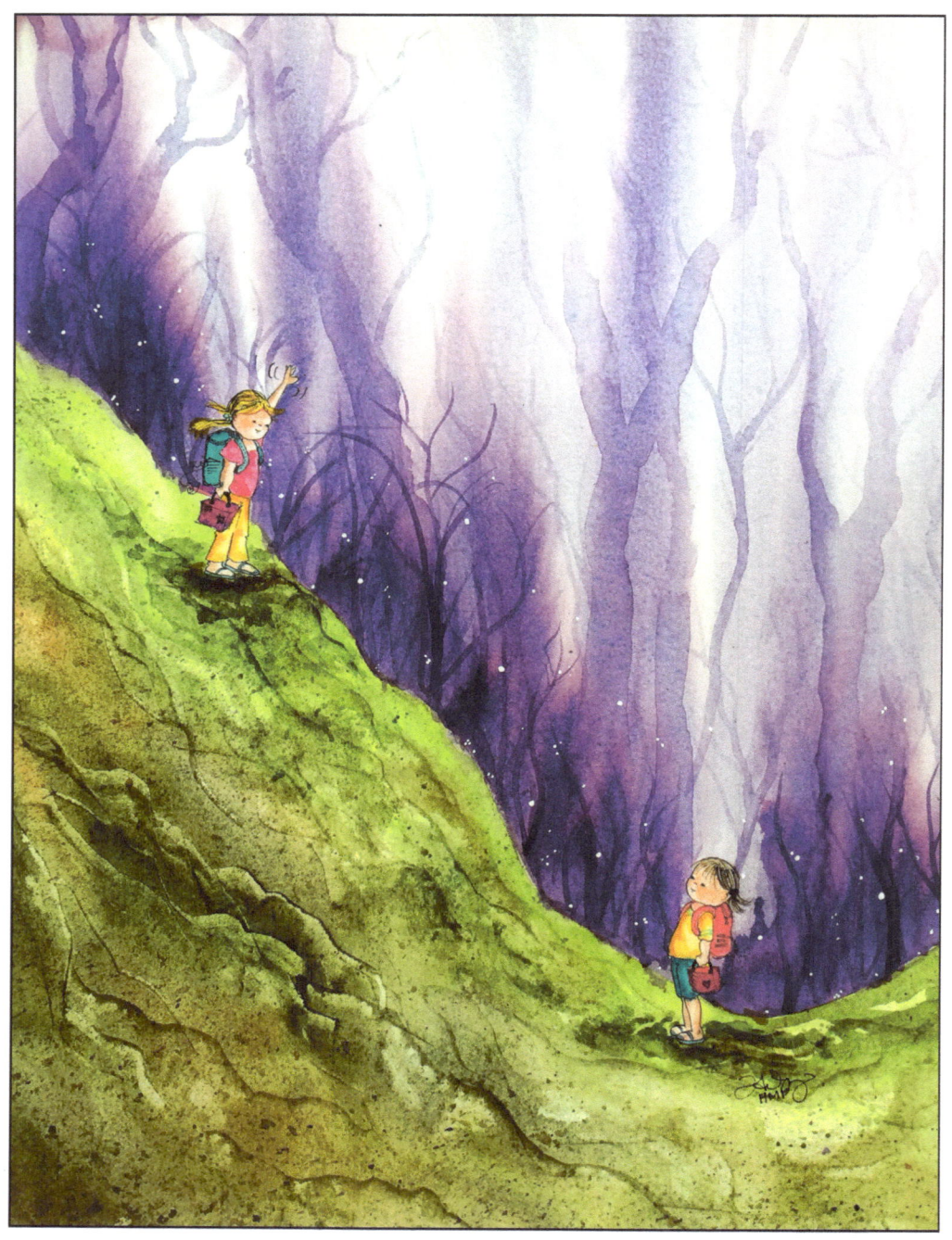

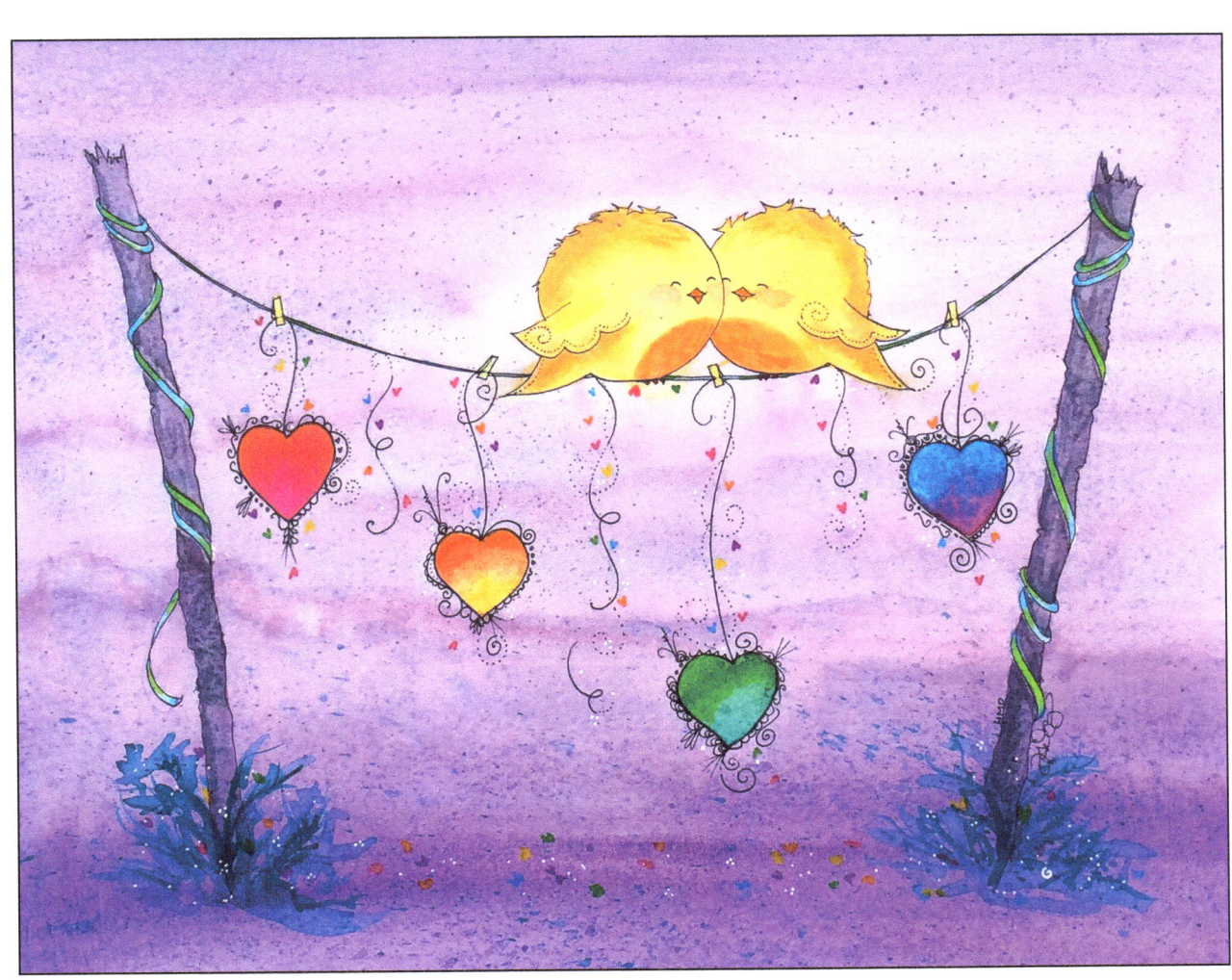

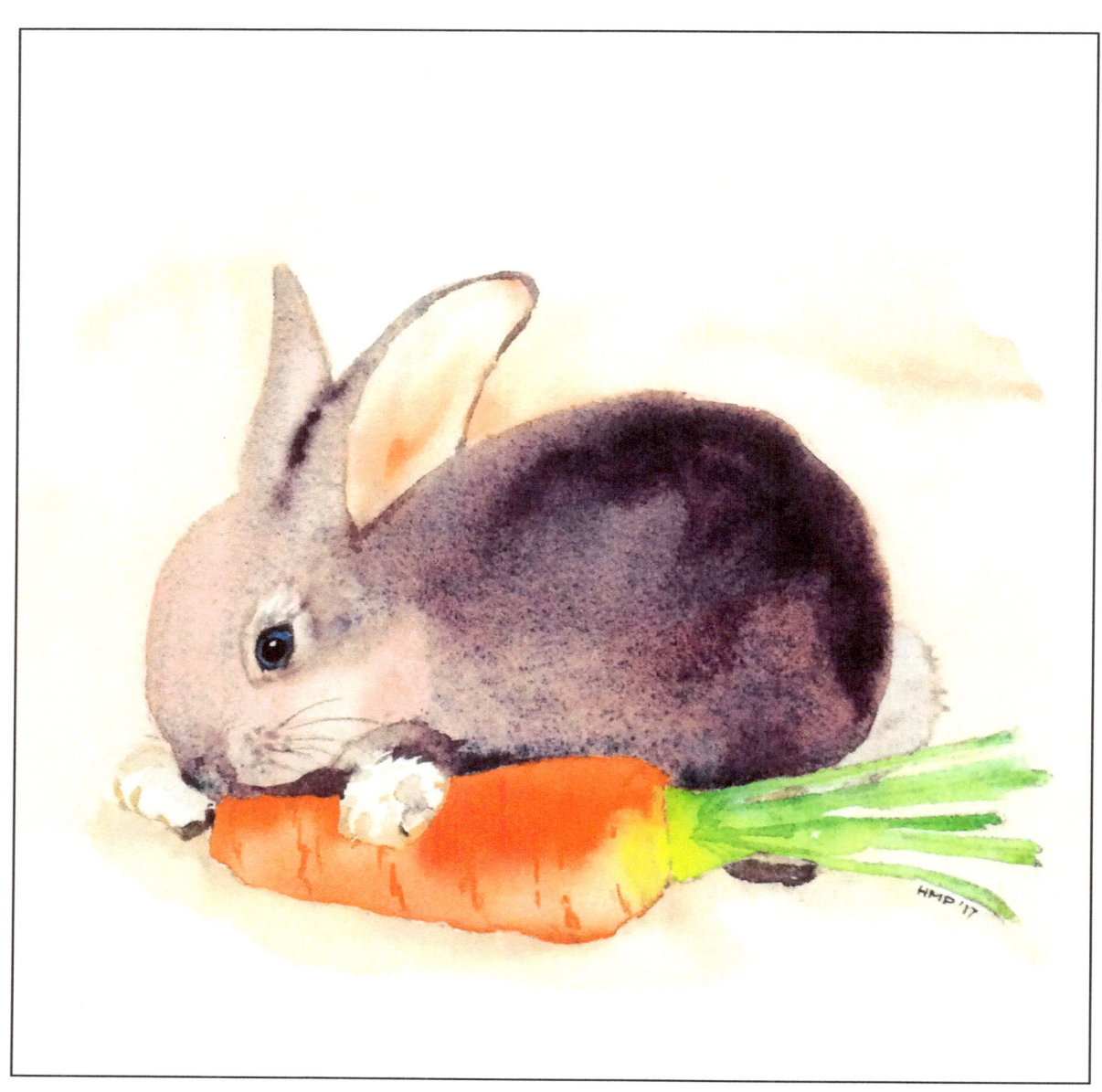

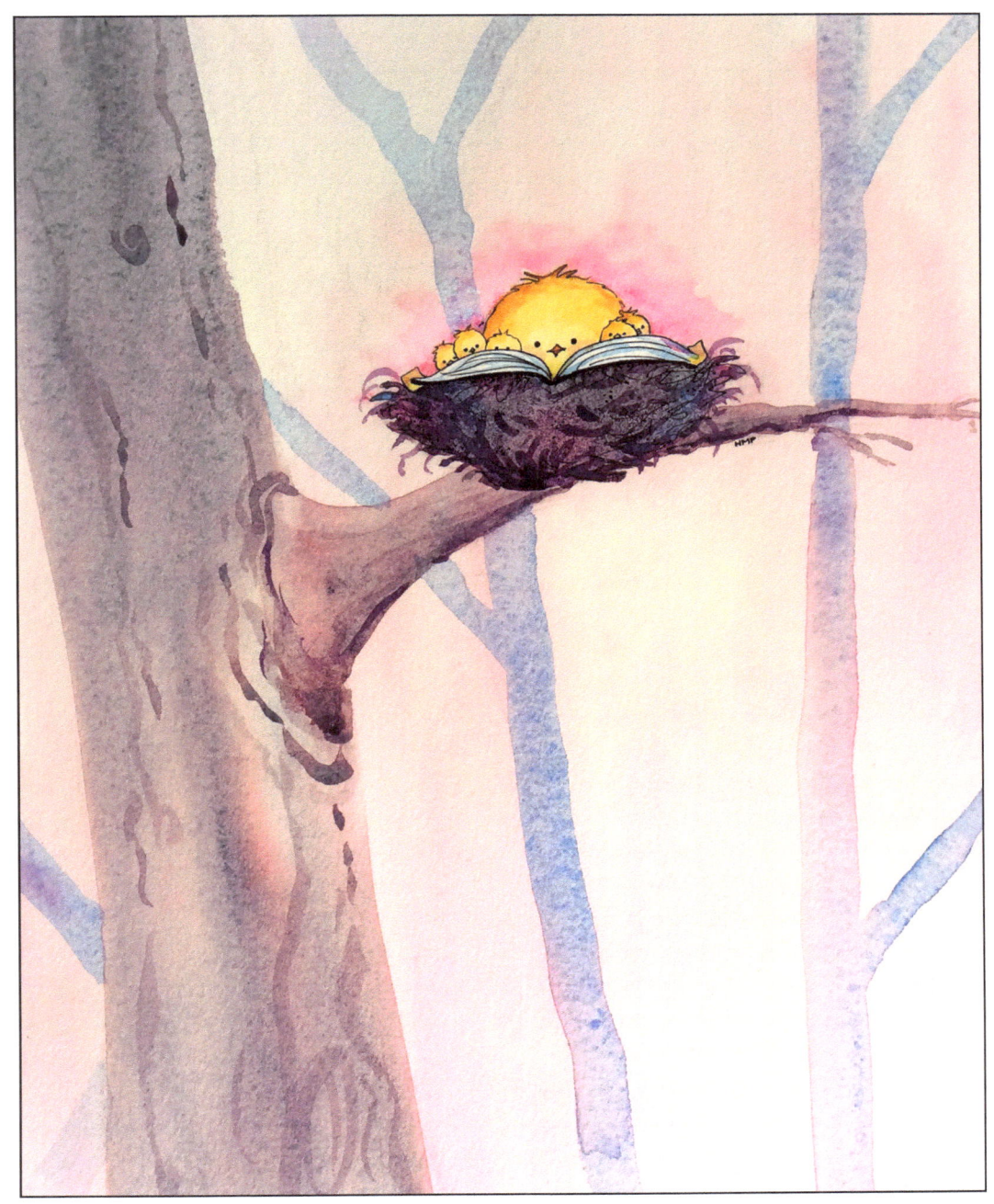

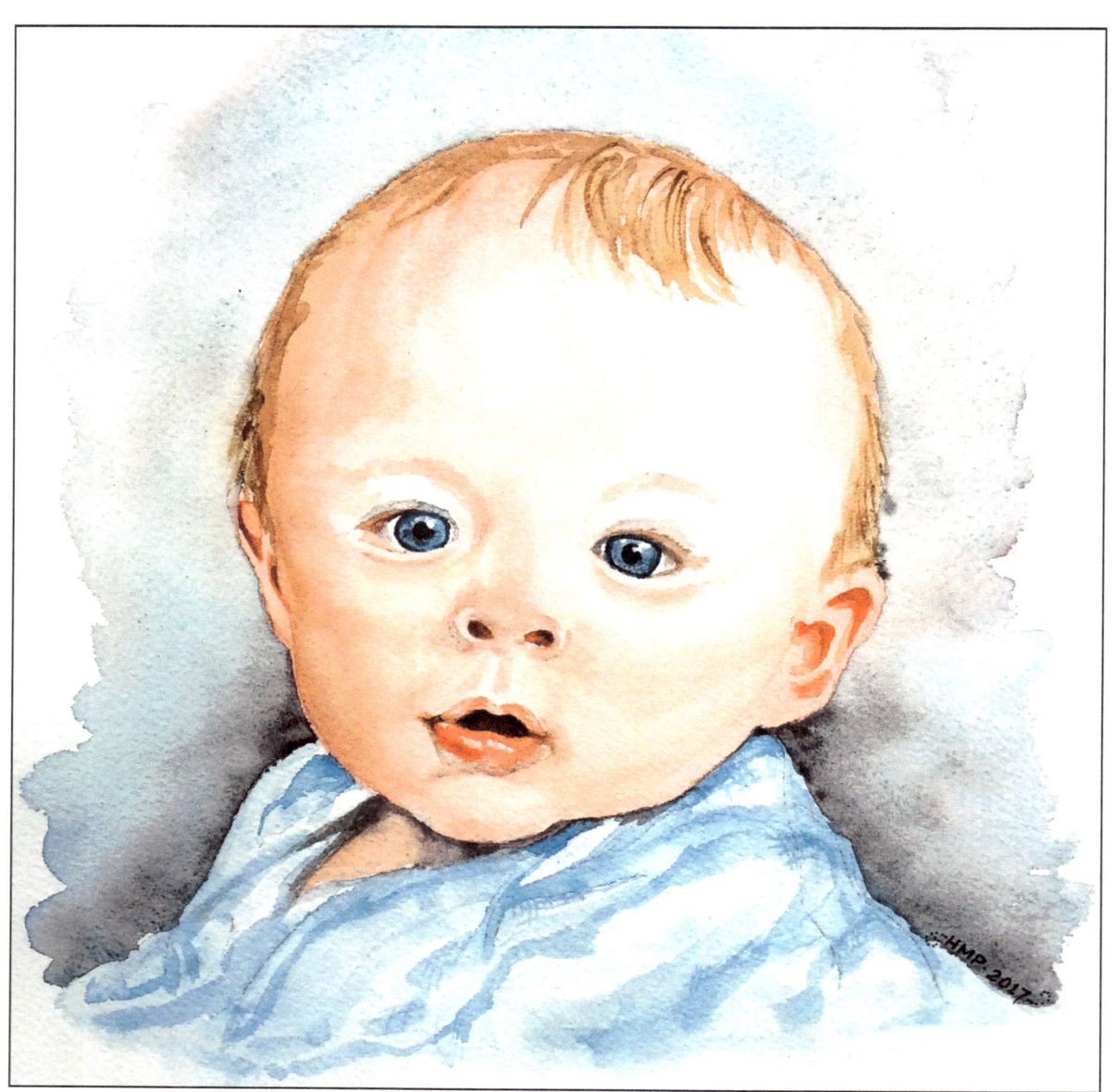

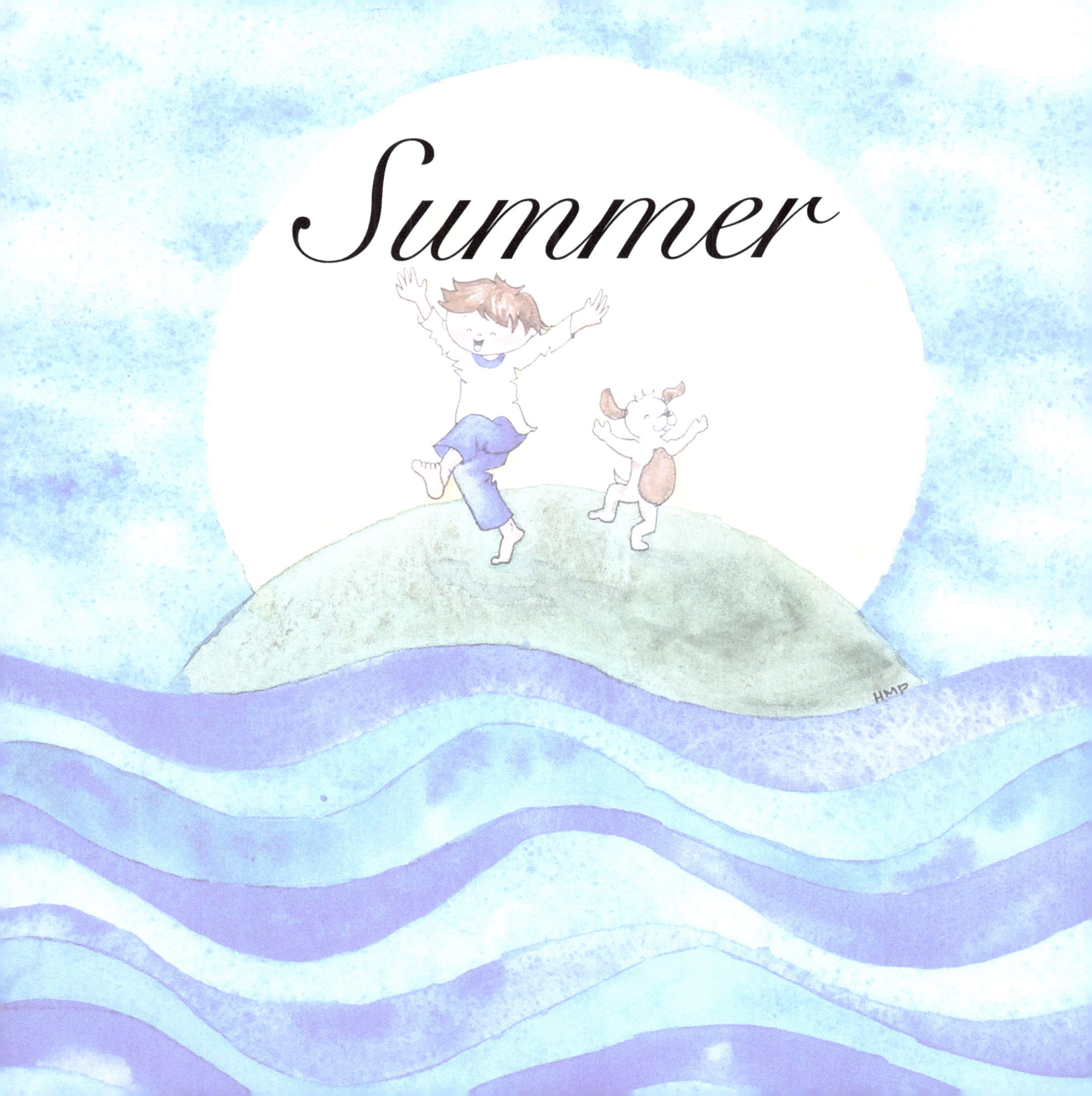

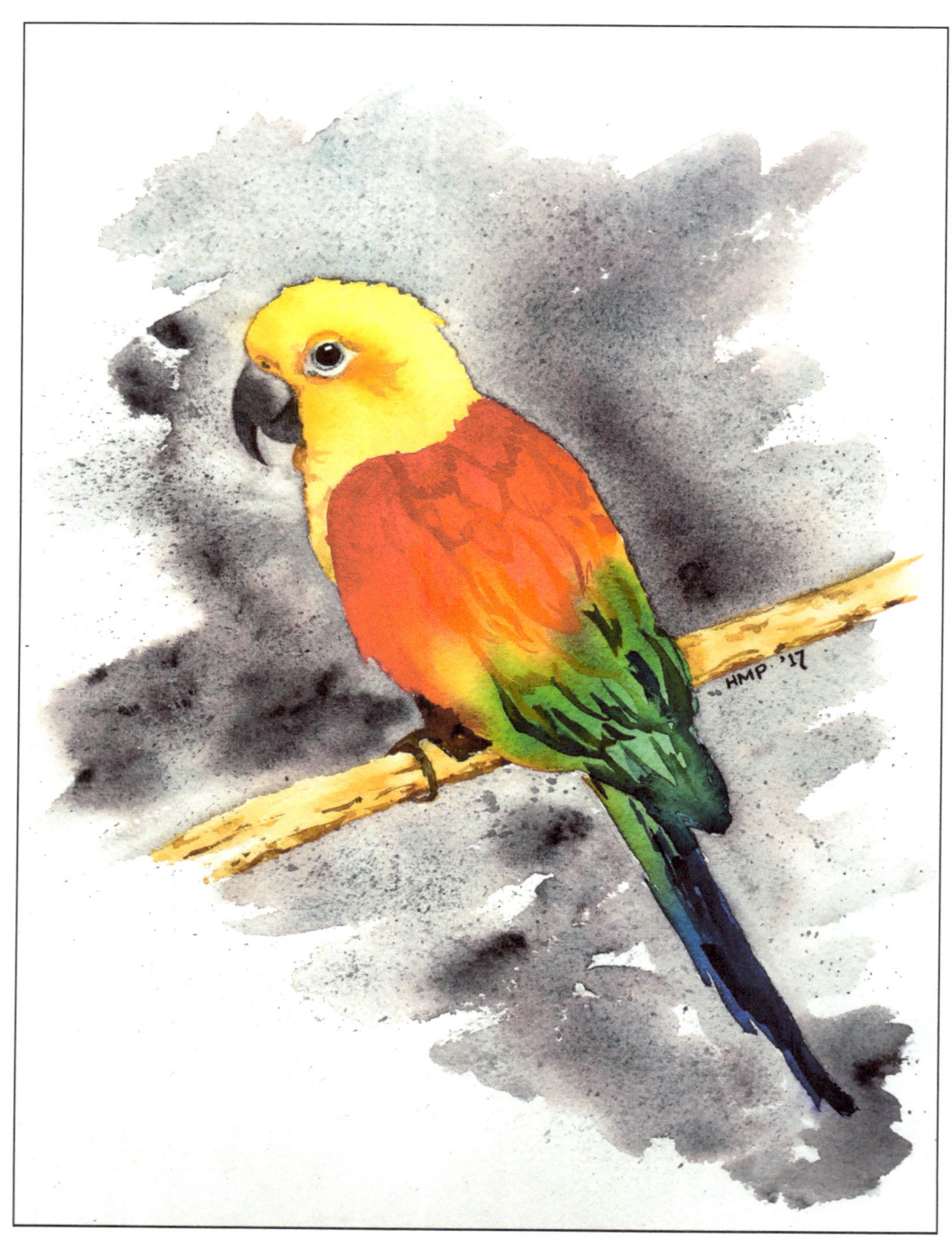

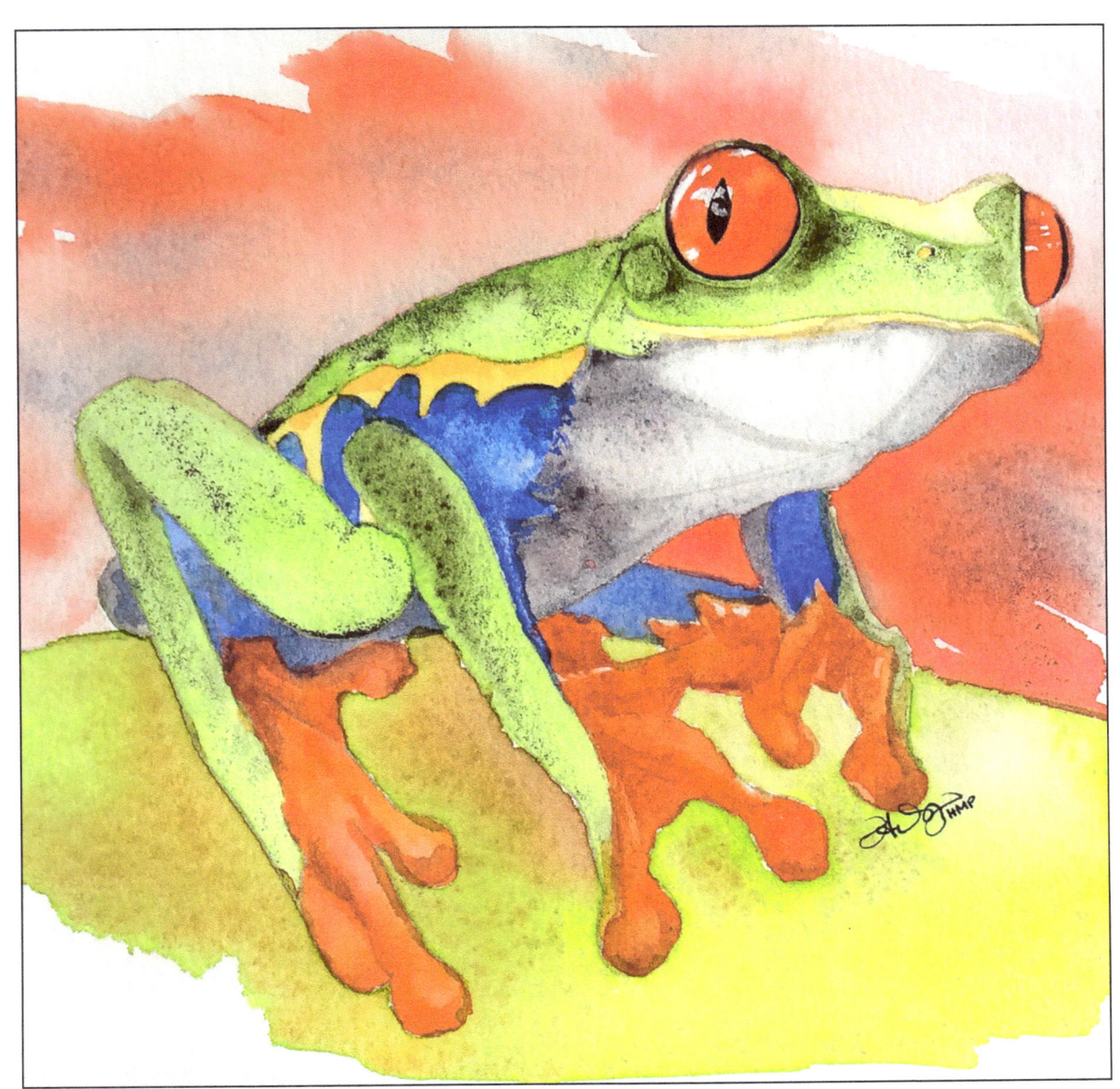

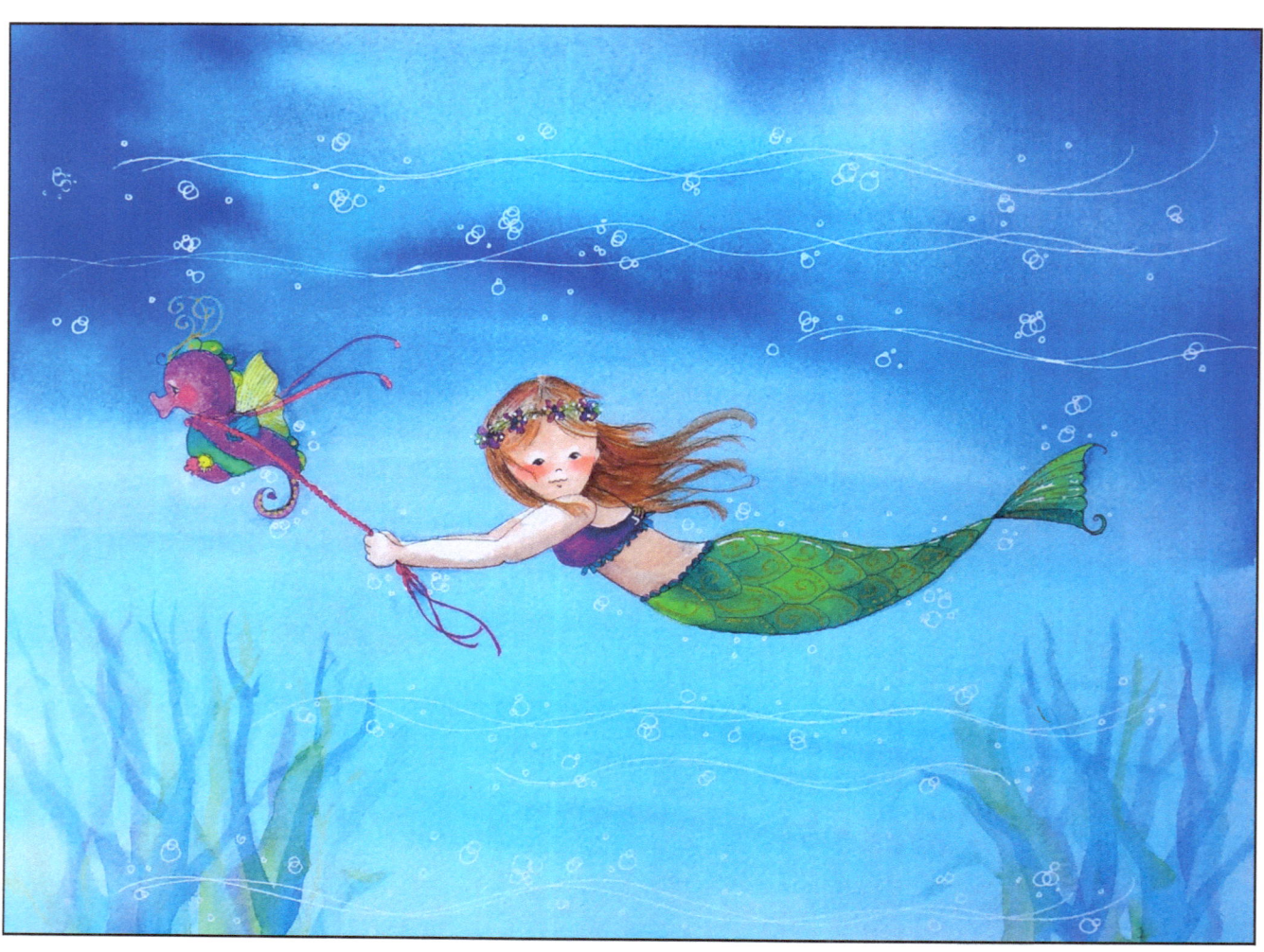

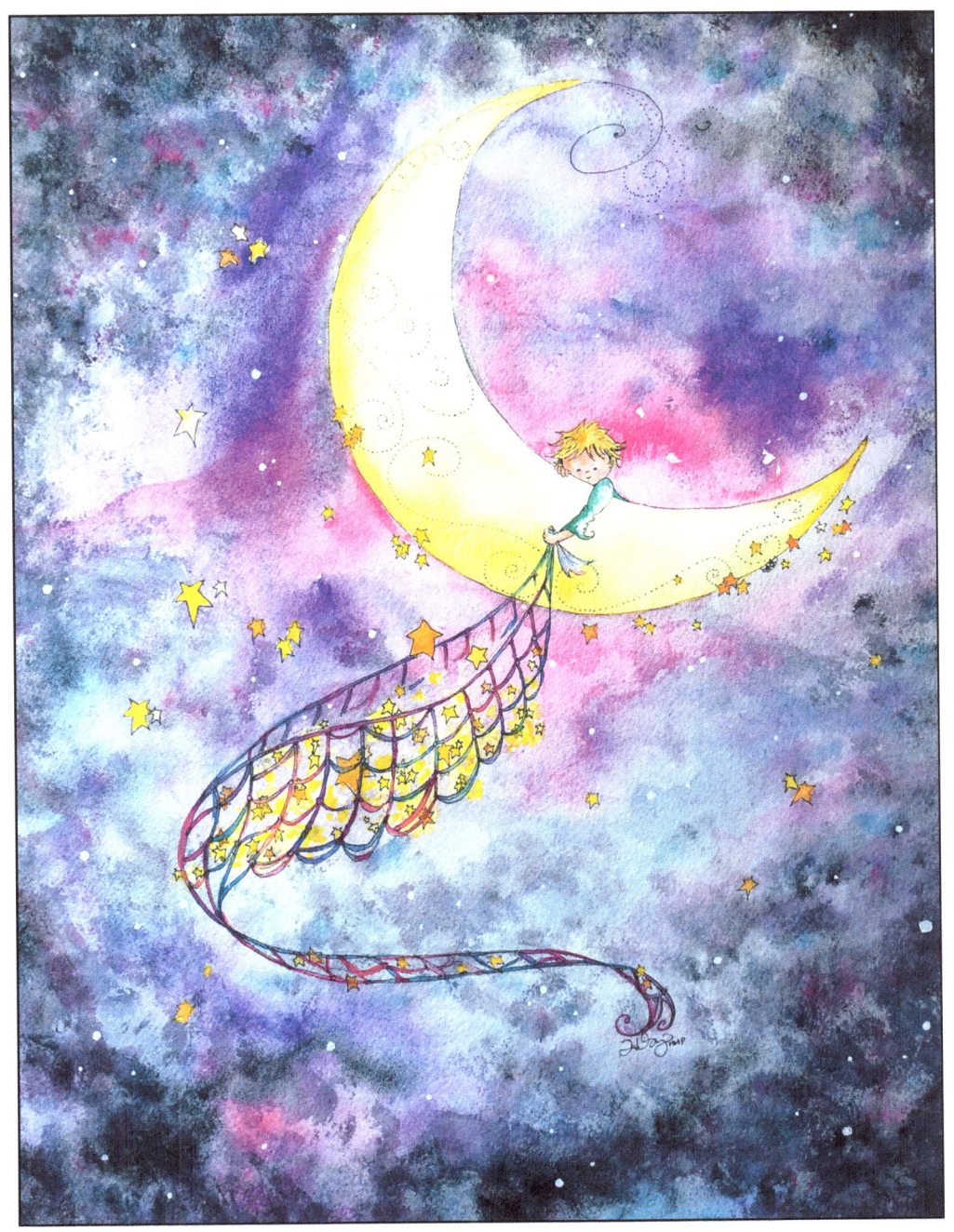

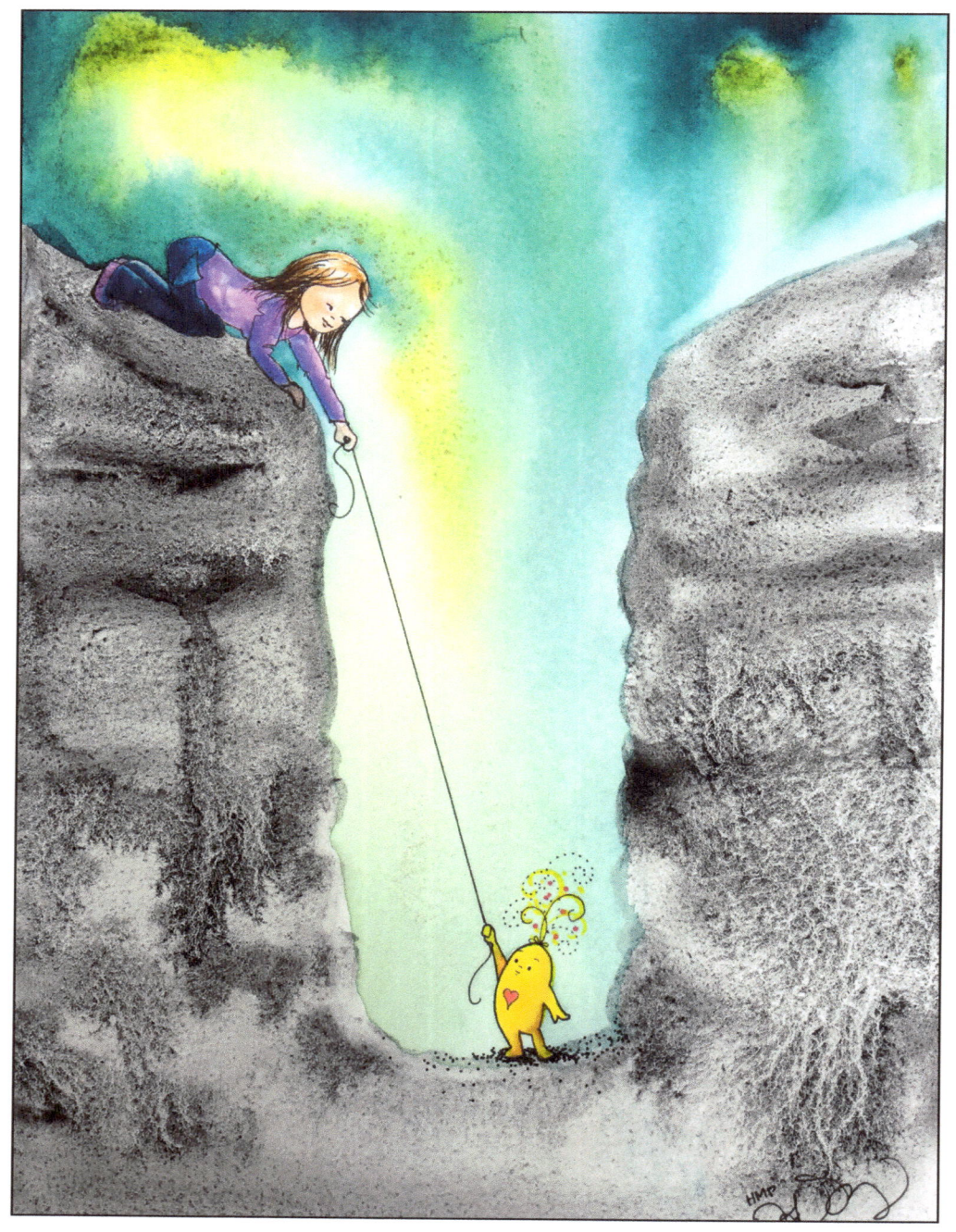

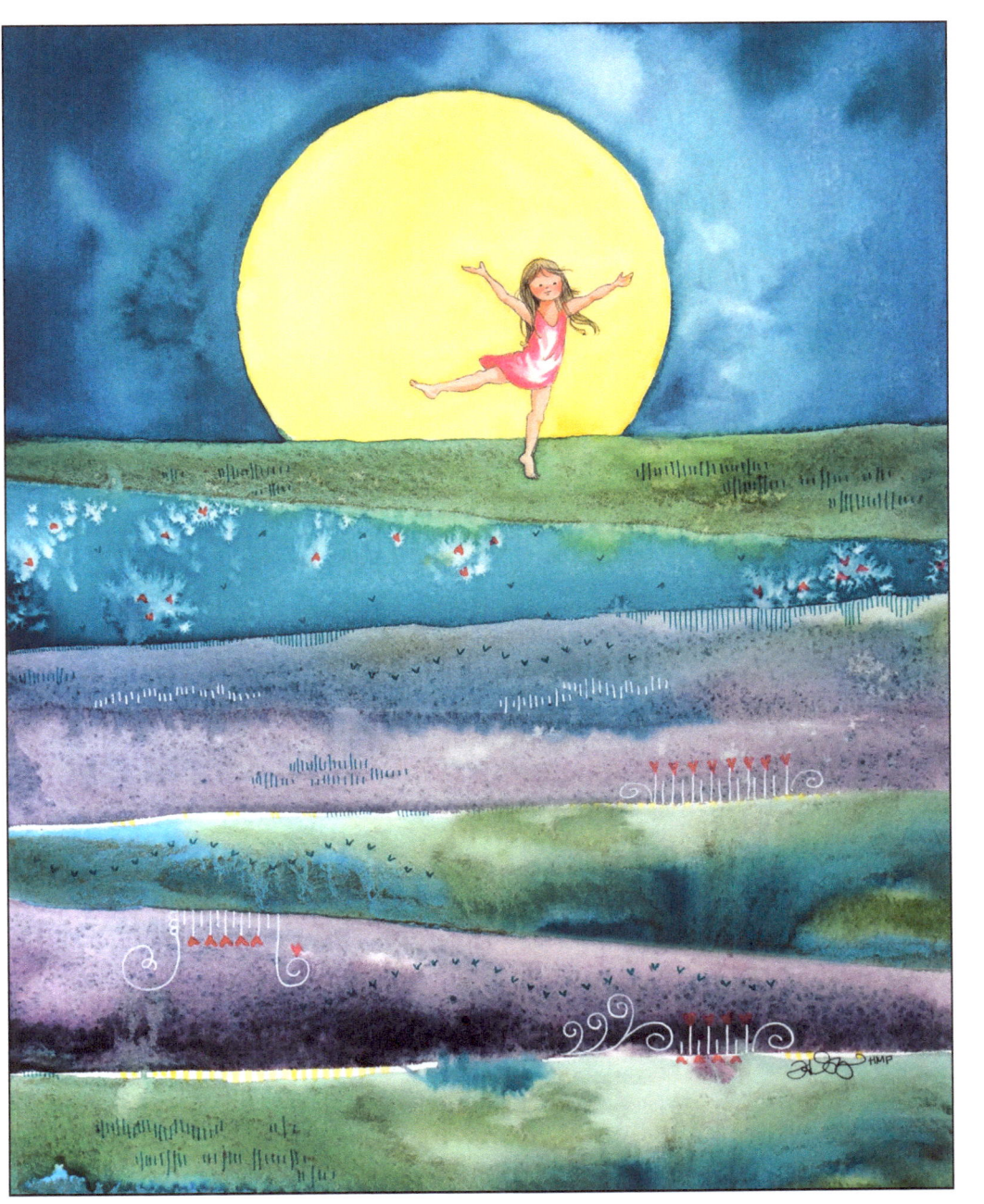

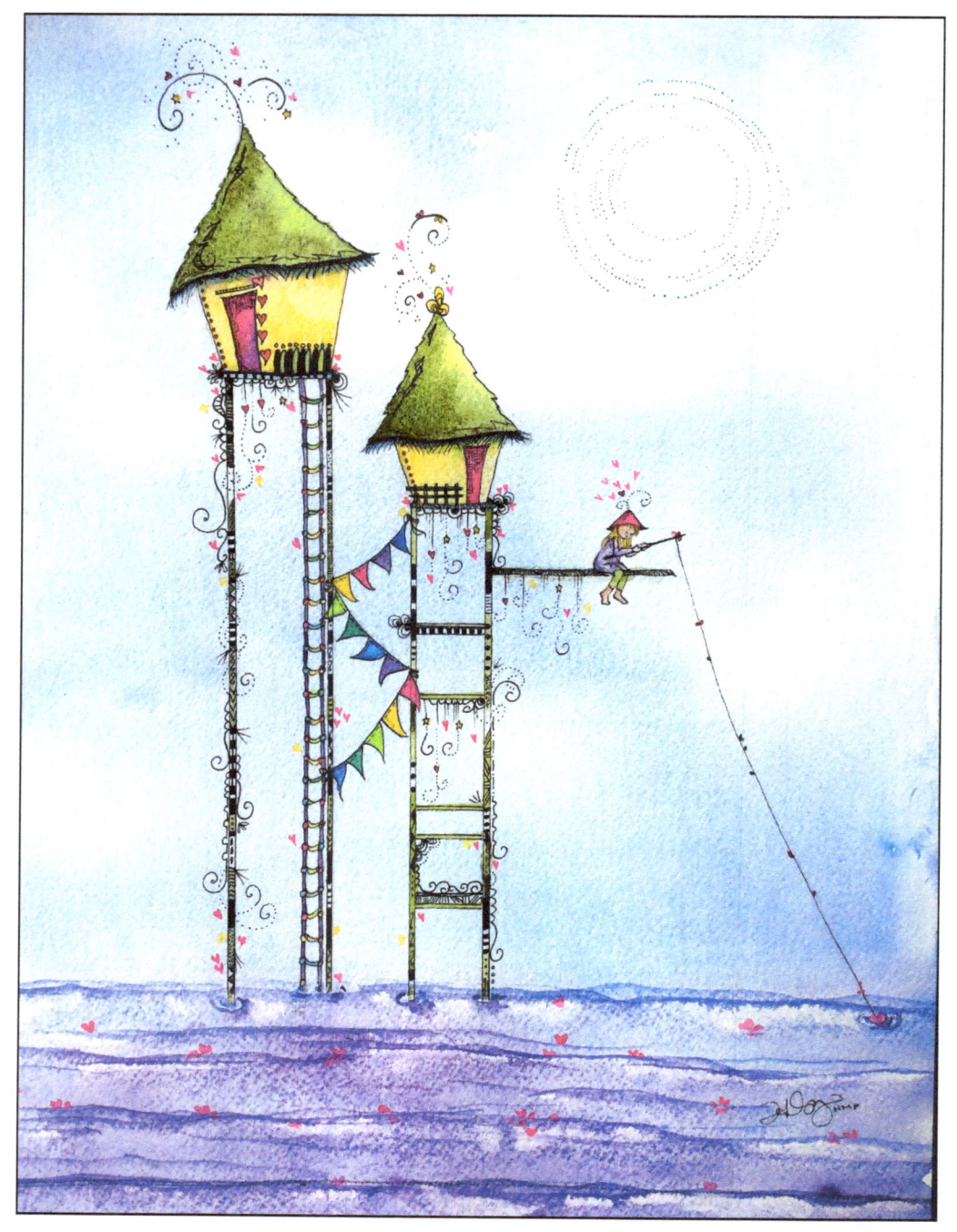

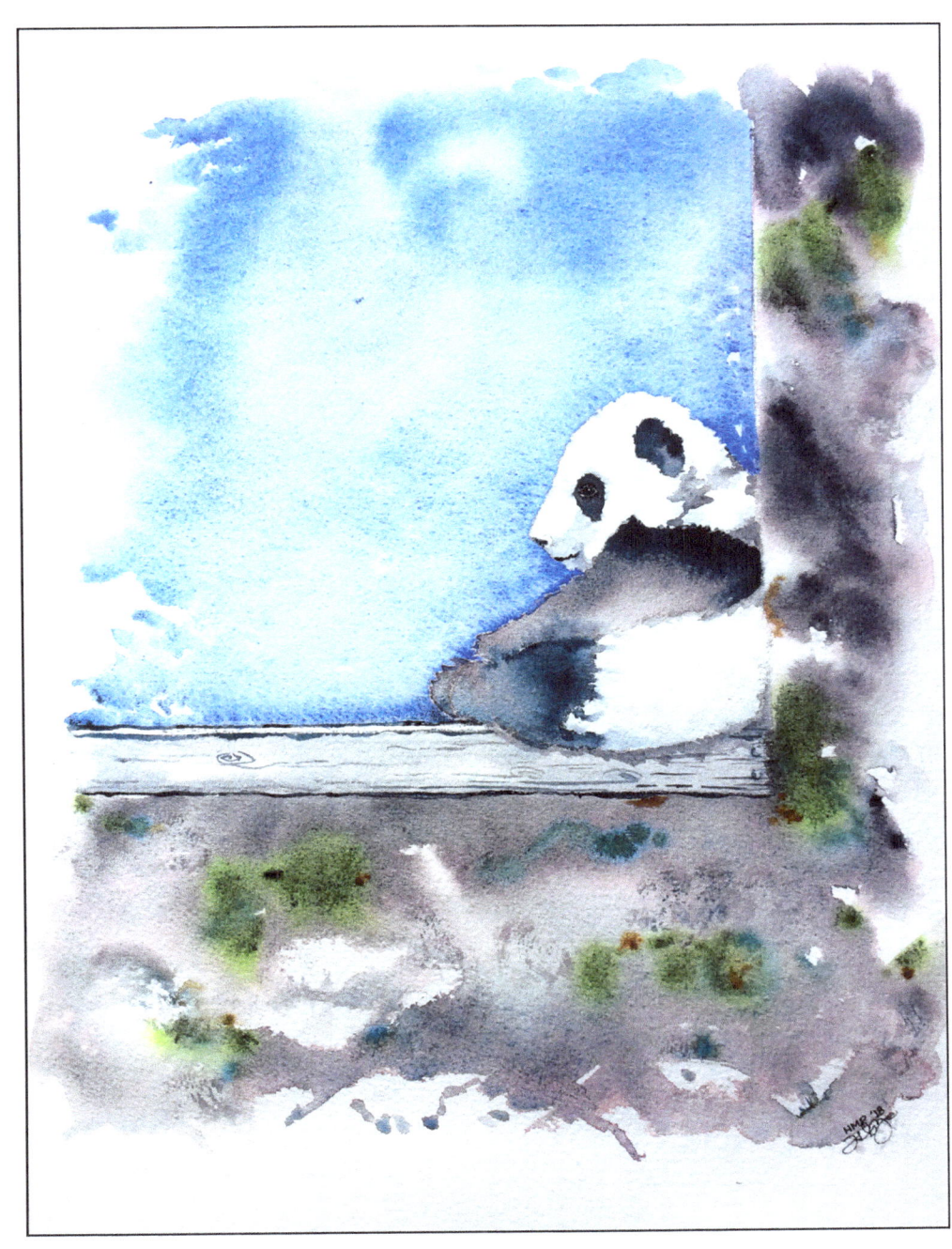

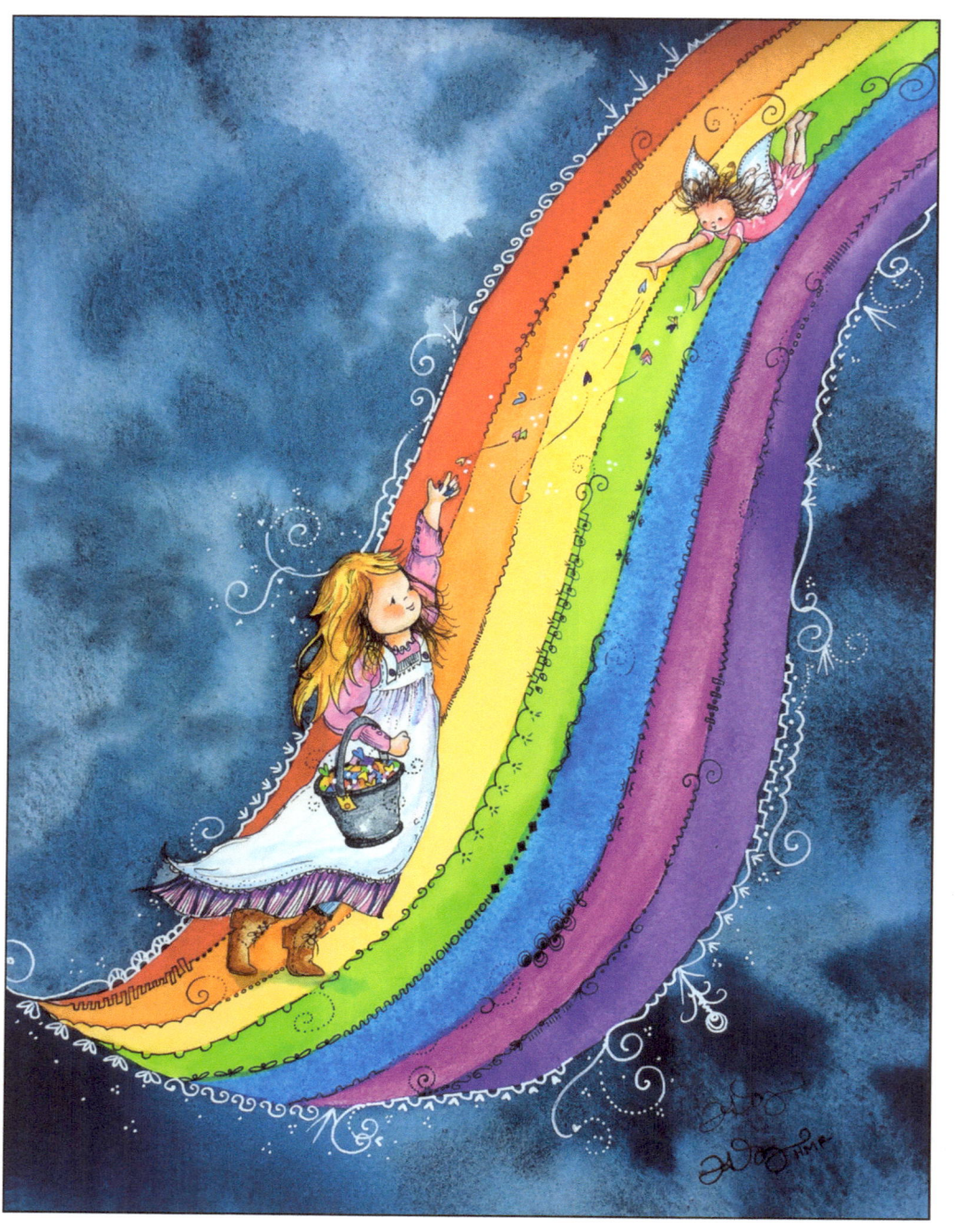

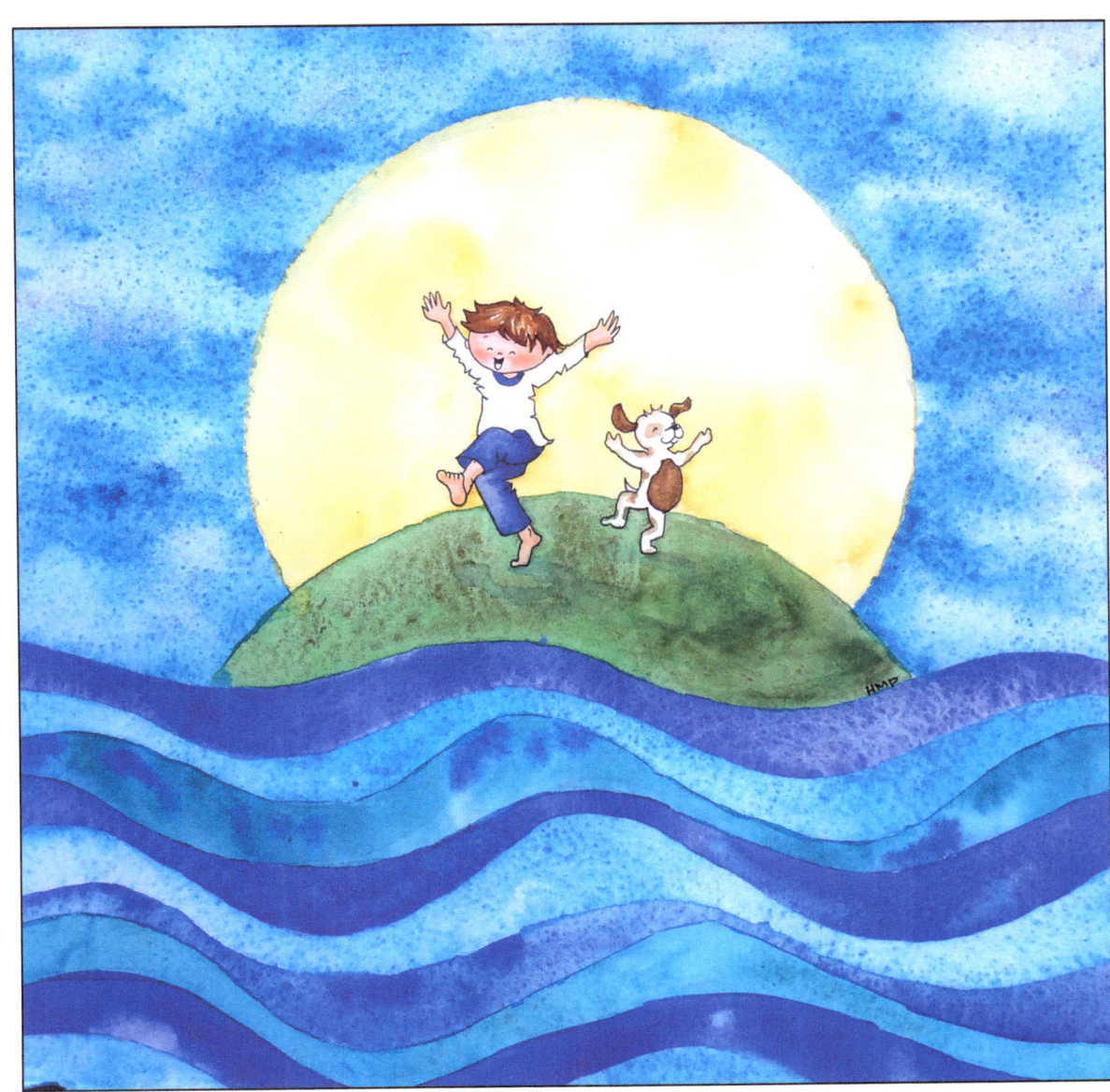

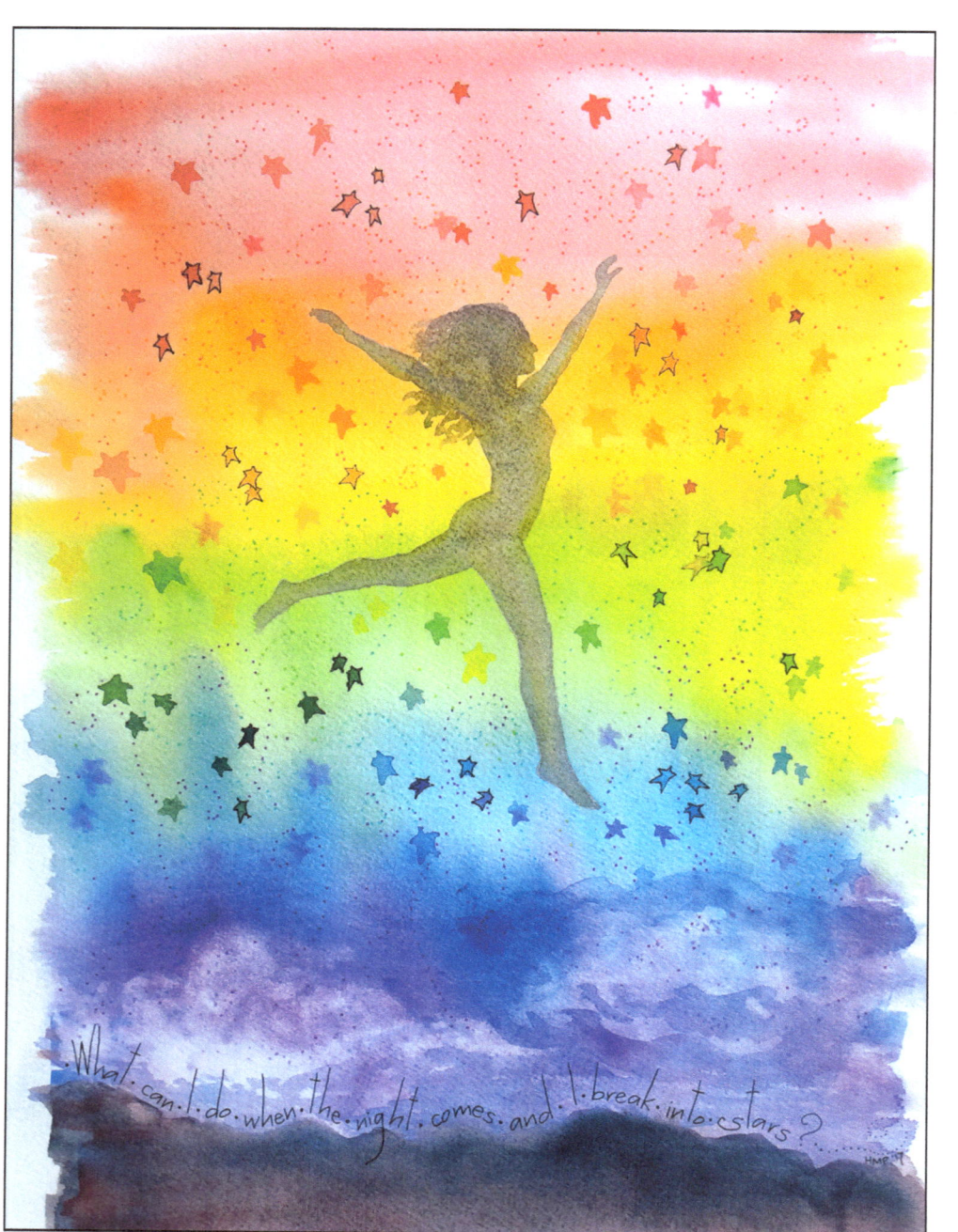

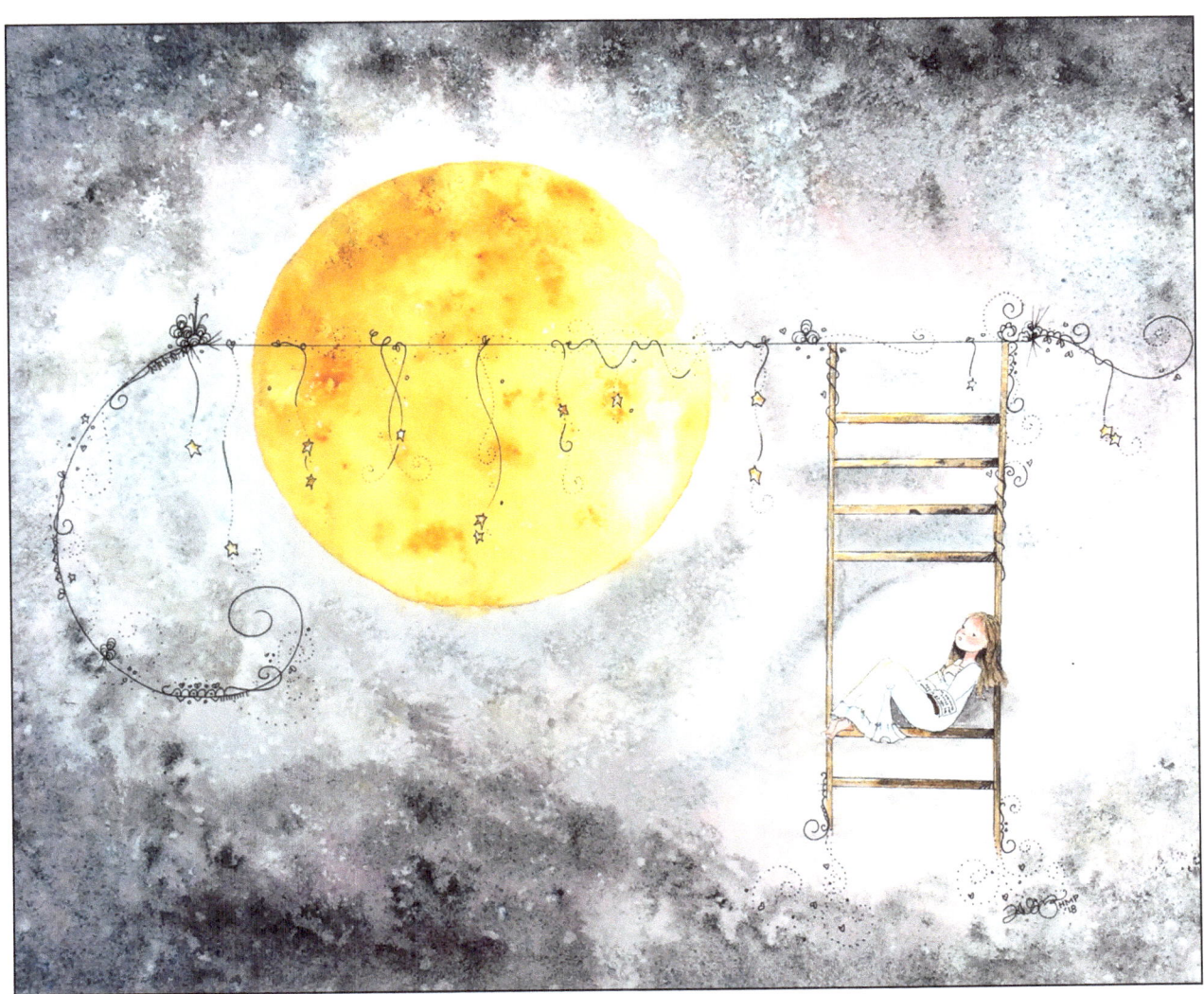

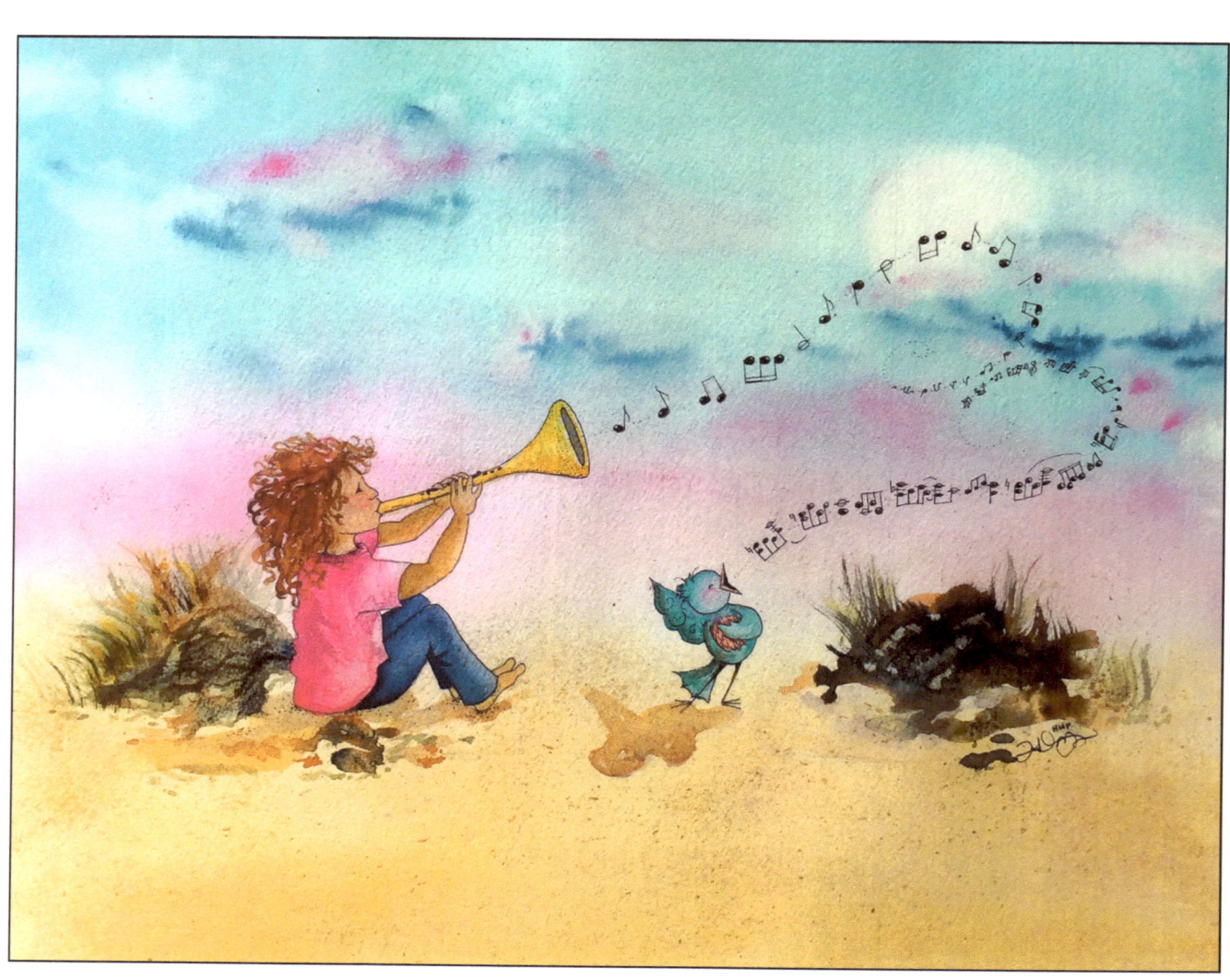

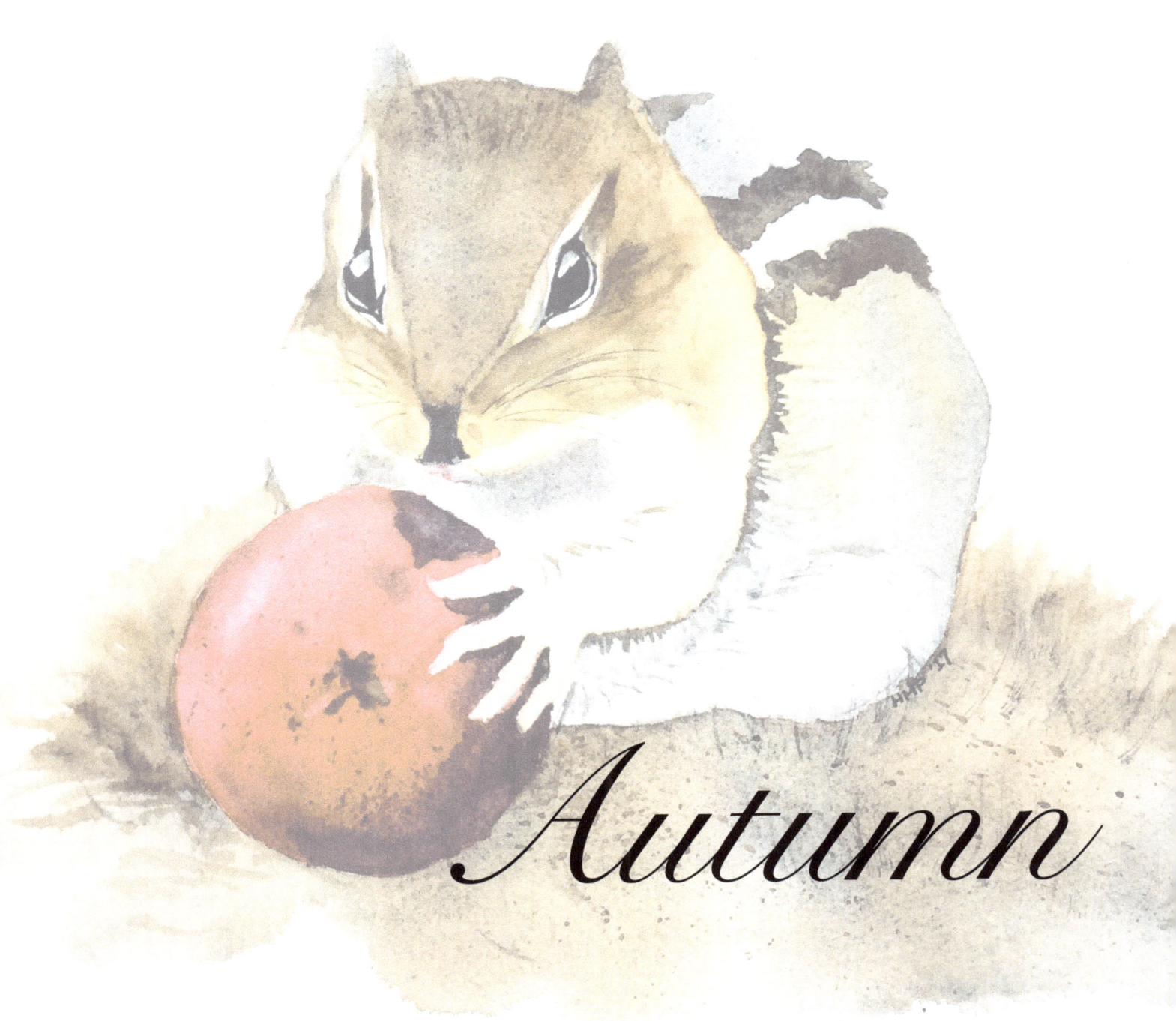

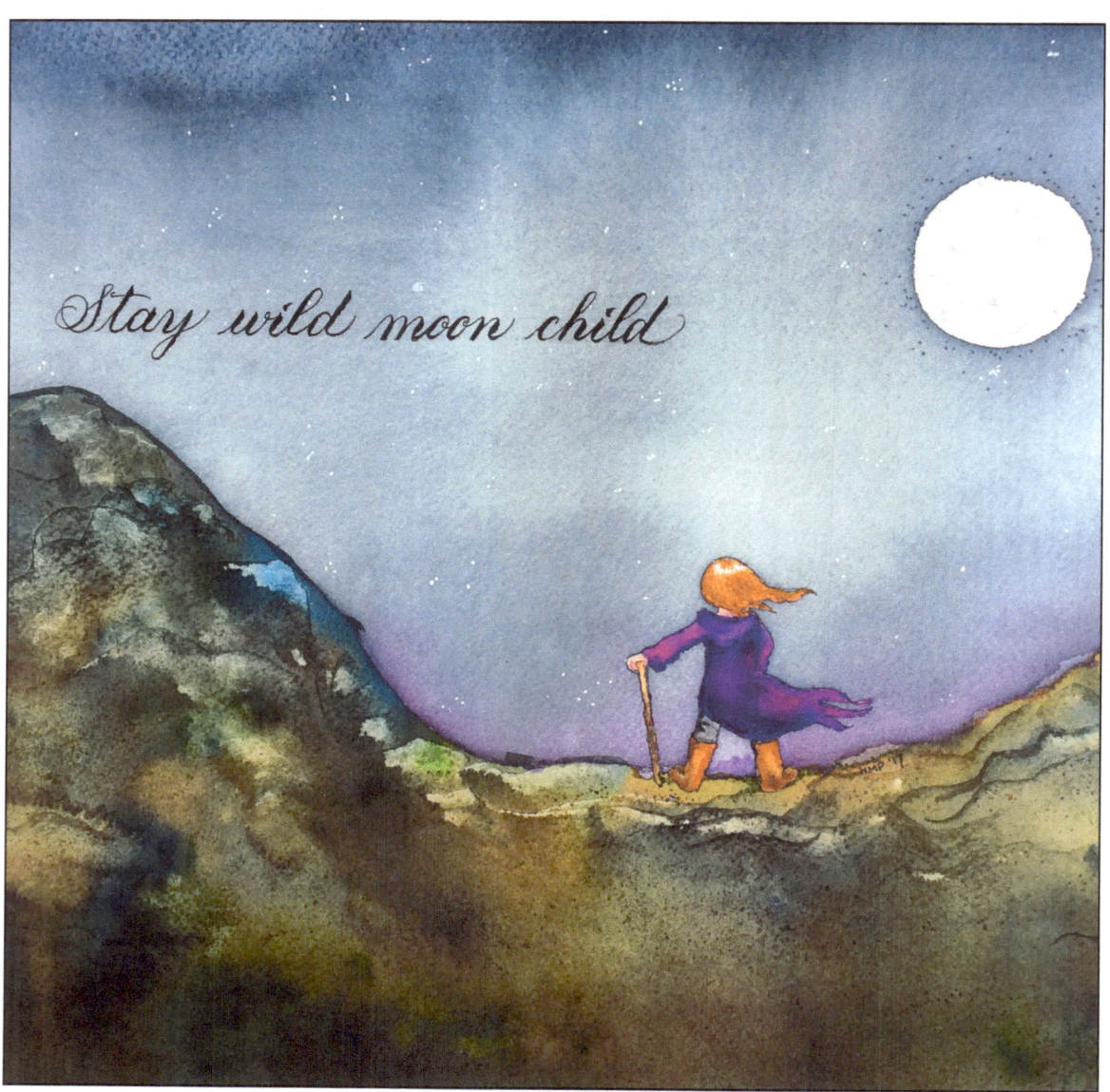

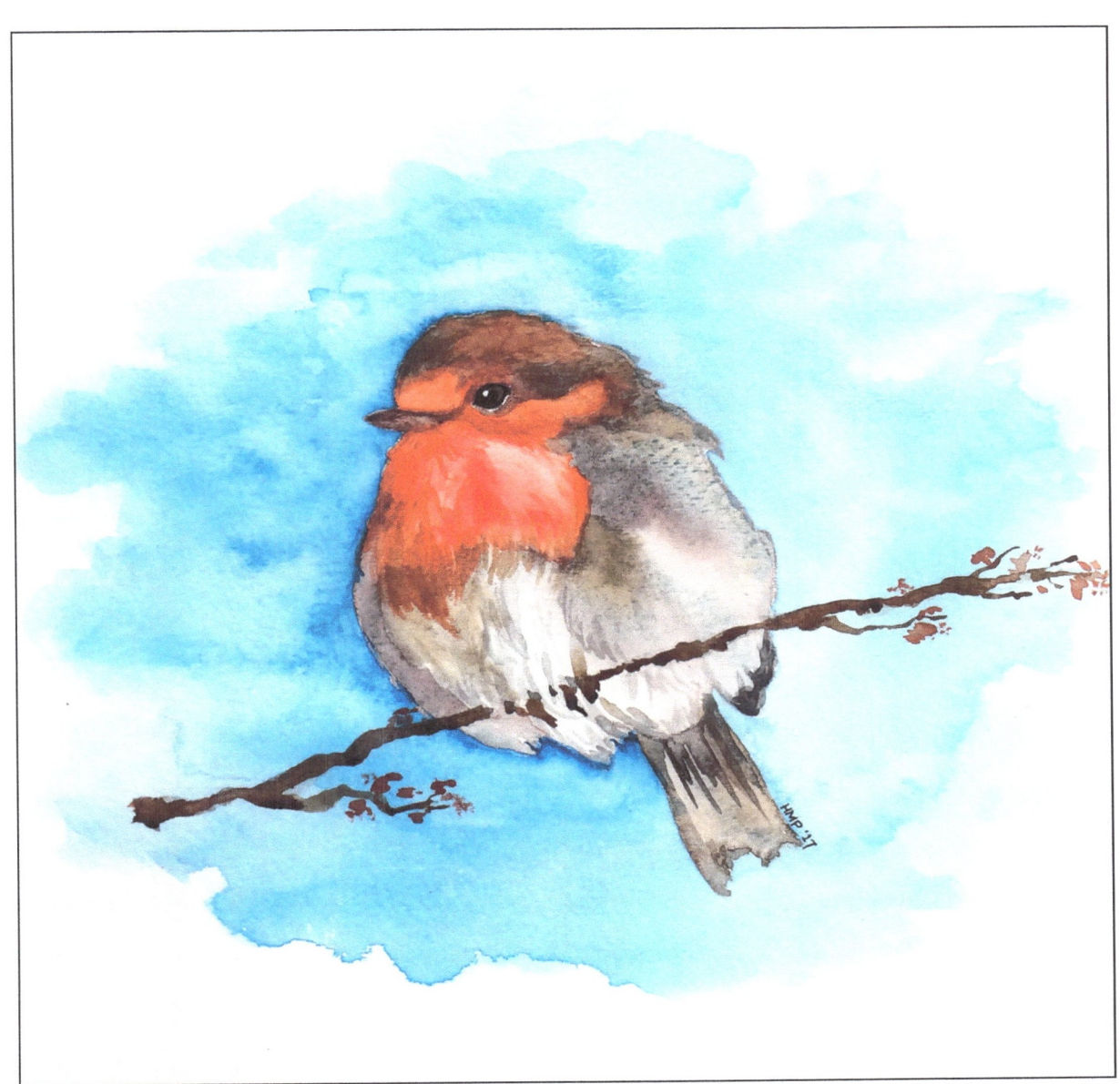

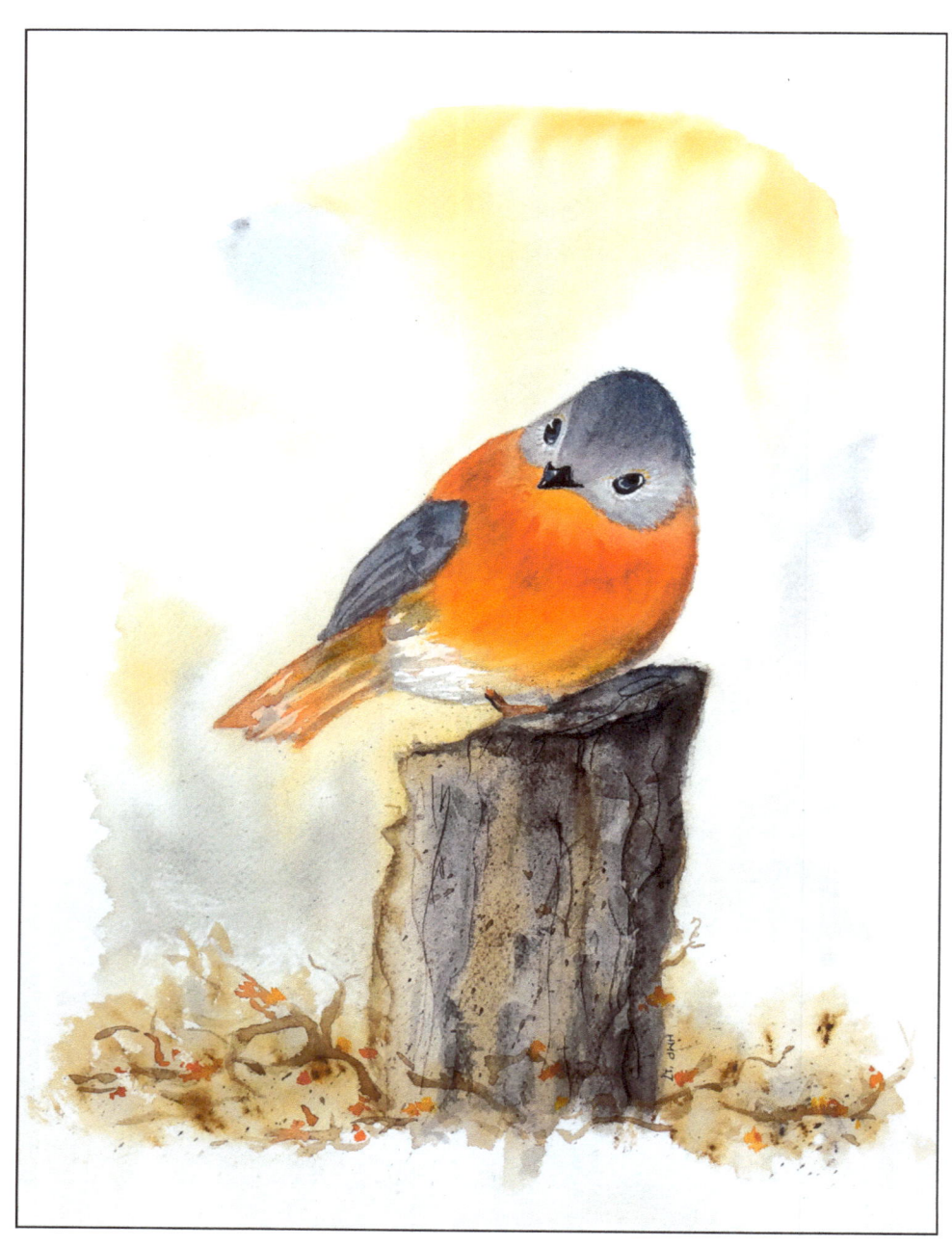

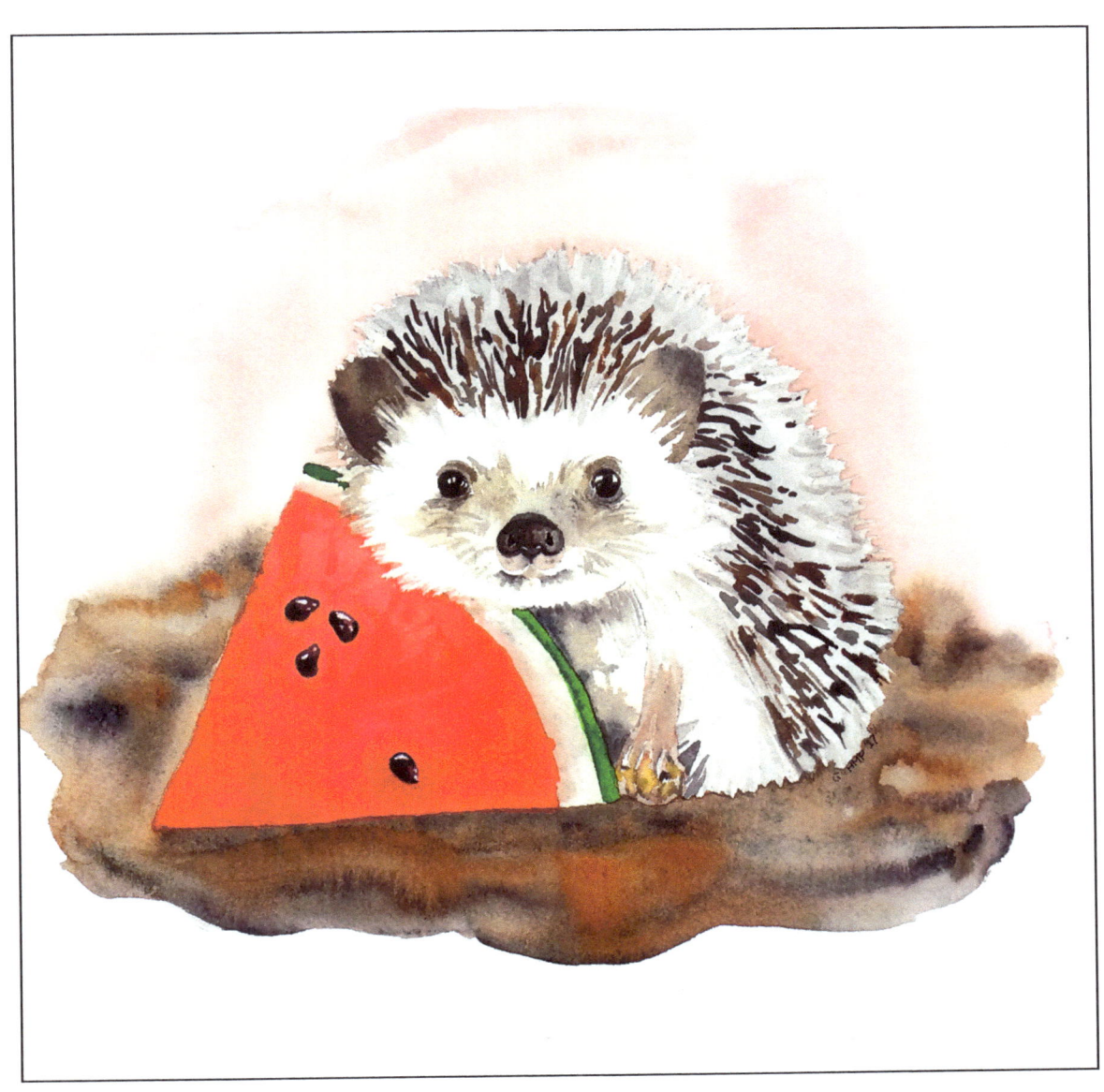

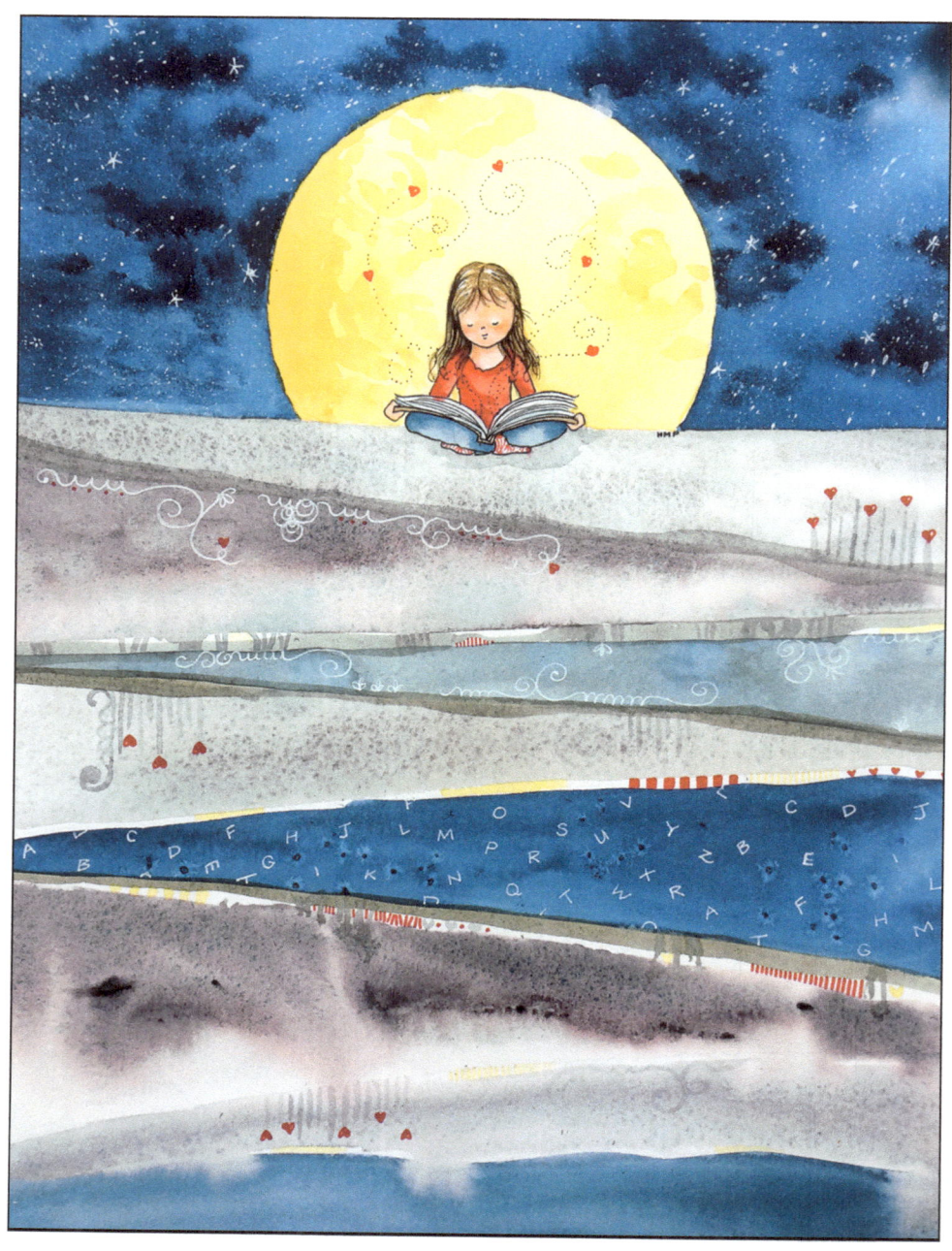

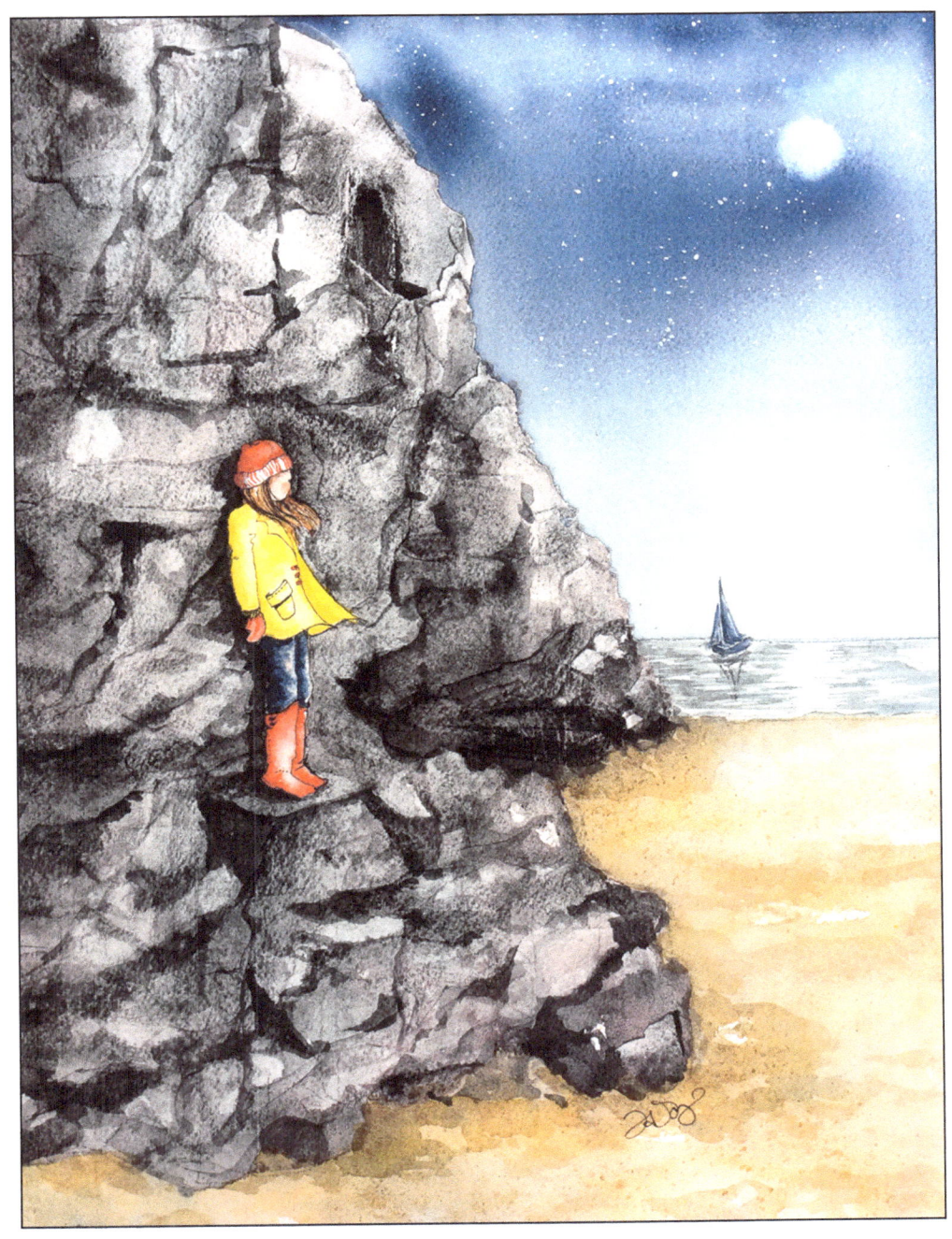

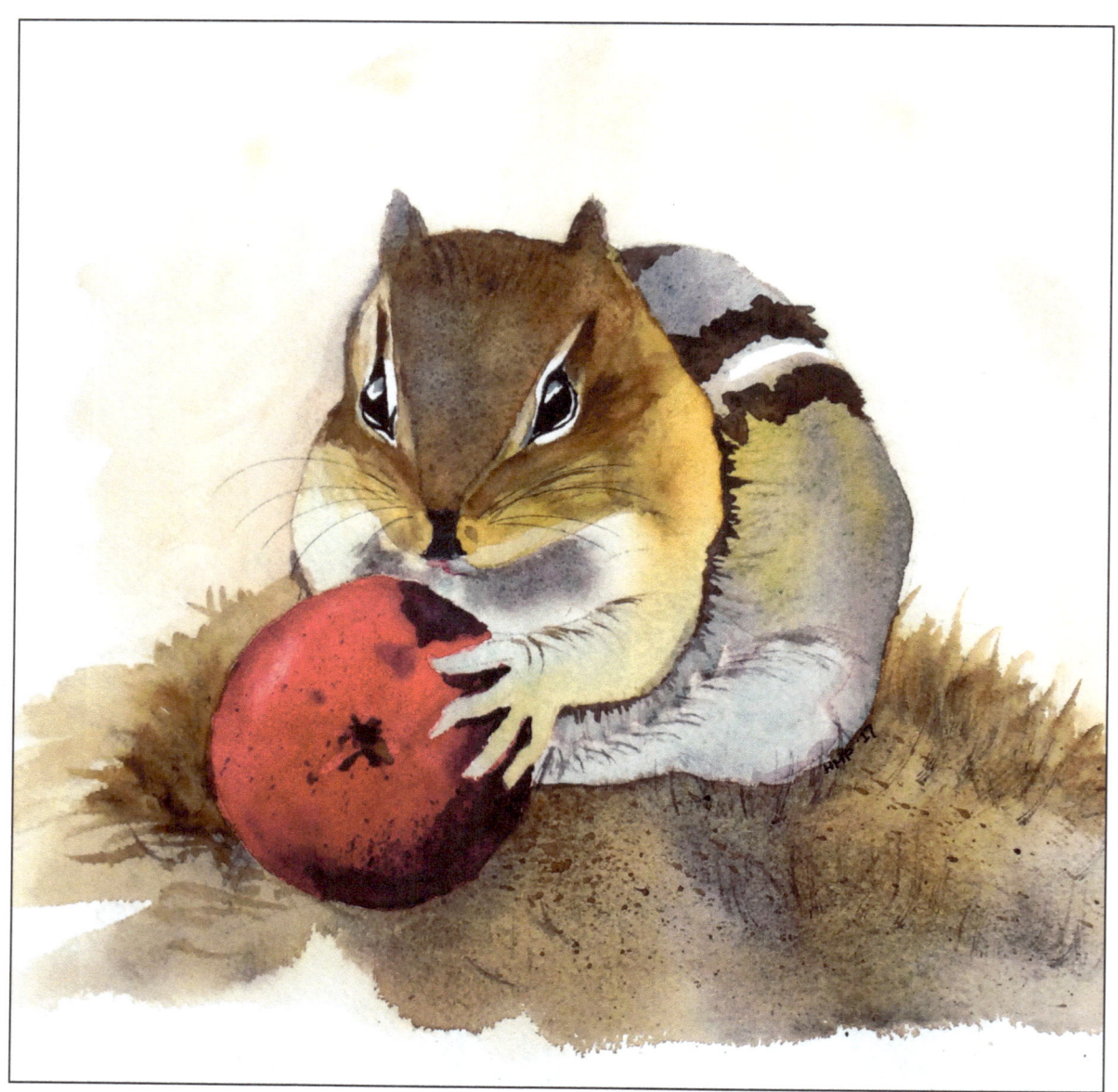

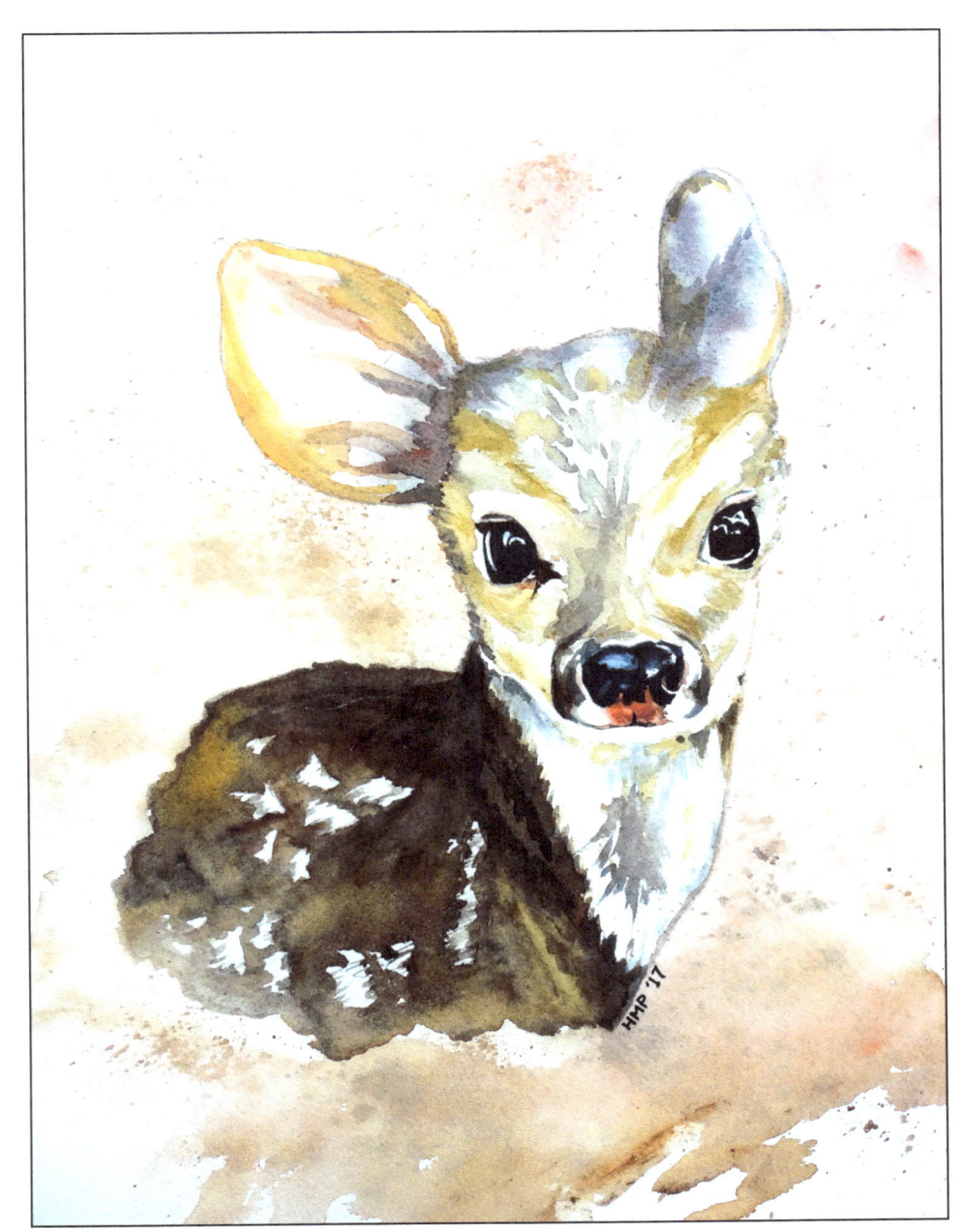

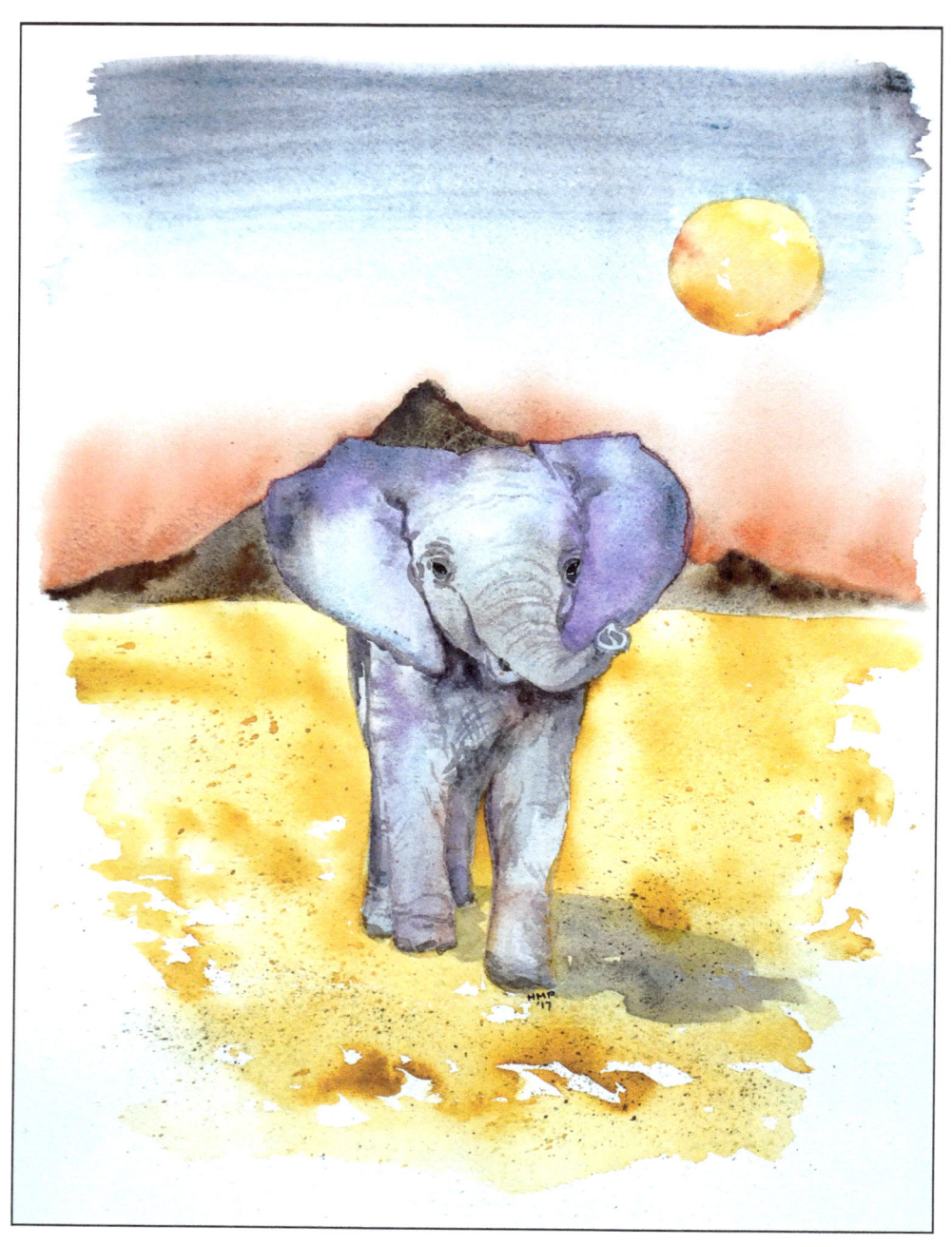

She answered,
　　"Gilgamesh, where are you hurrying to?
You will never find the life for which you are looking.
When the gods created man
　　　　they alloted to him death,
　　but life they retained in their own keeping.
　　　　As for you, Gilgamesh,
　　　fill your belly with good things;
day and night, night and day, dance and be merry,
　　　　feast and rejoice.
　Let your clothes be fresh,
　　　　　　bathe yourself in water,
　cherish the little child that holds your hand,
　and make your wife happy in your embrace;
　　　for this too is the lot of man."

For Molly

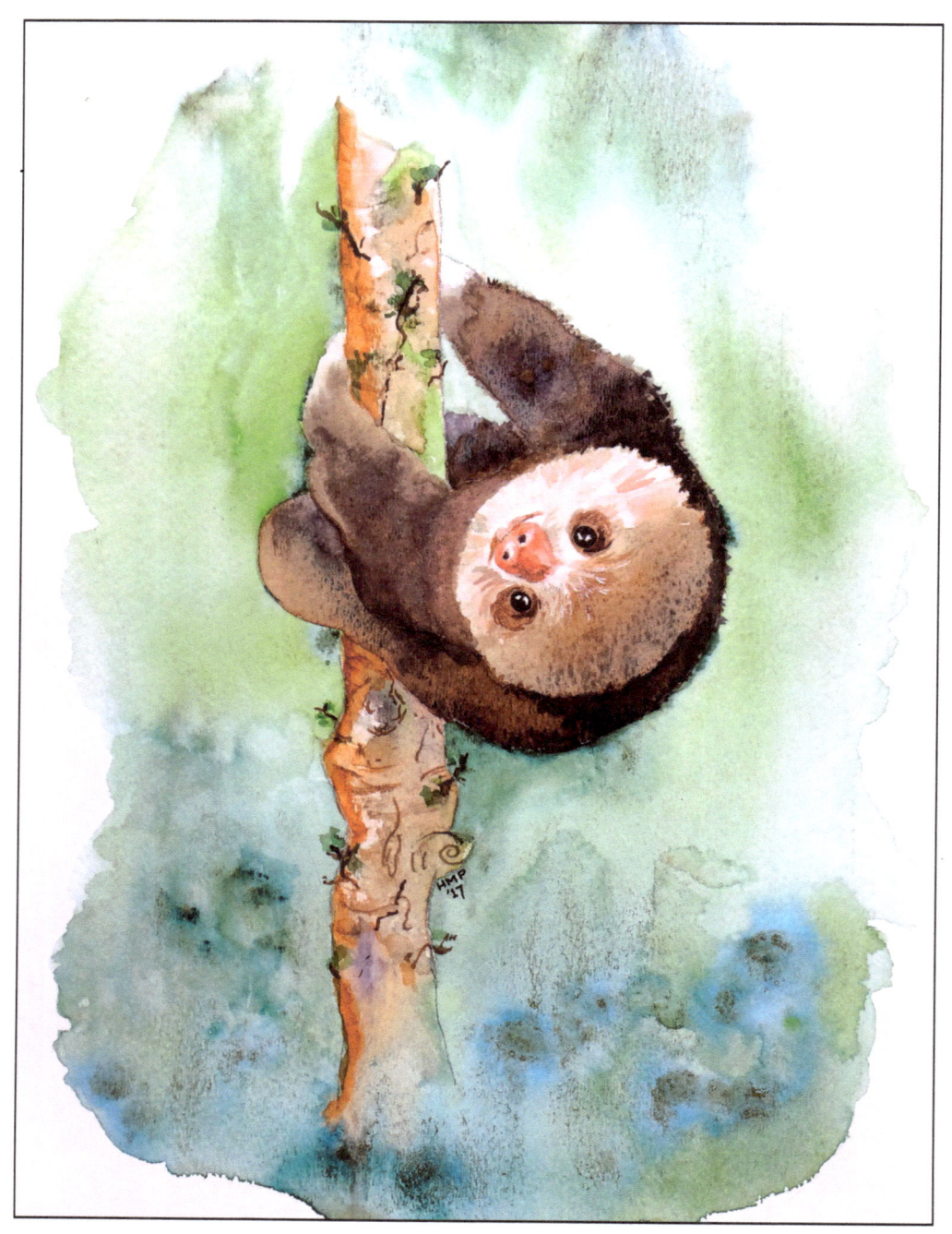

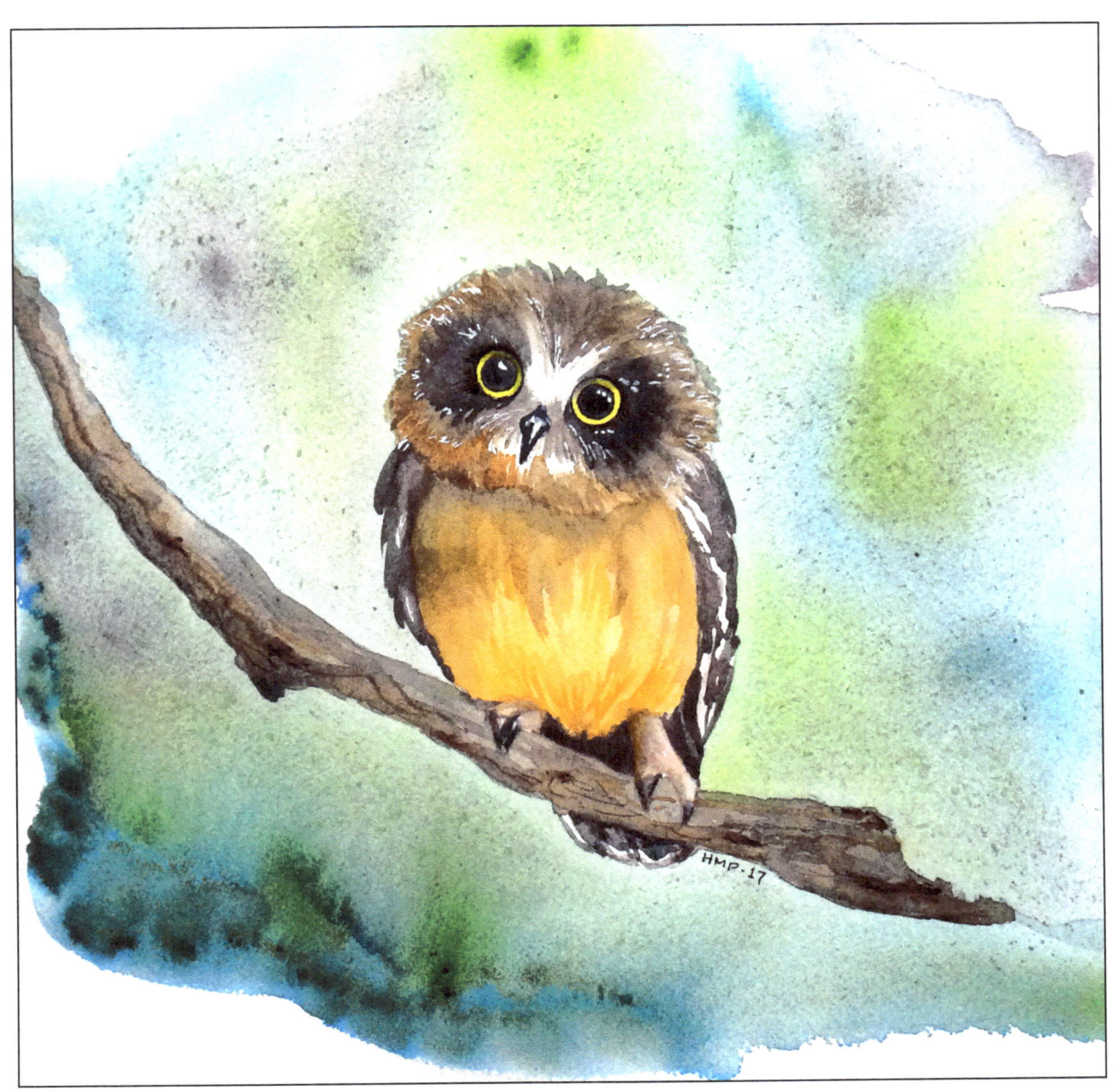

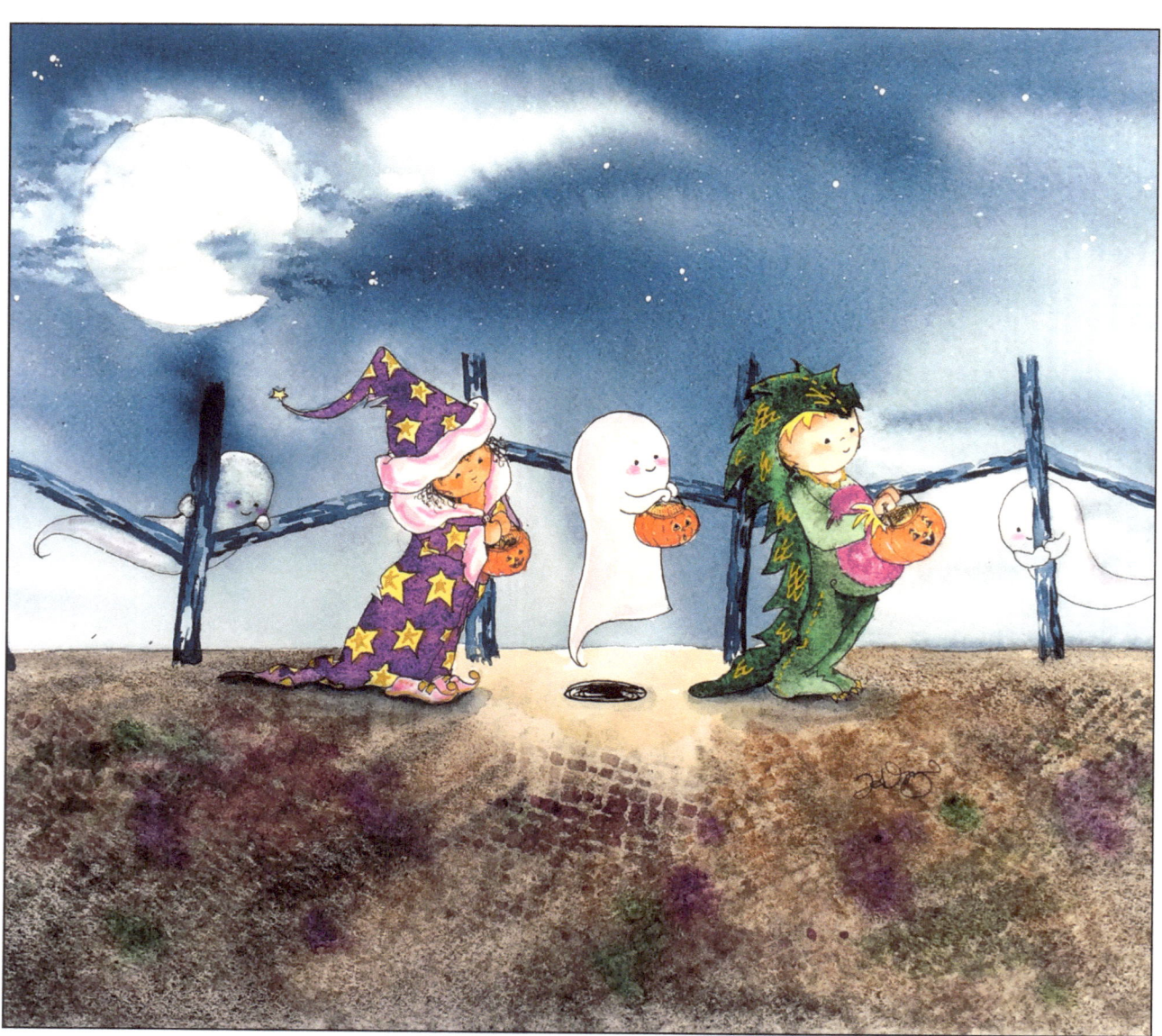

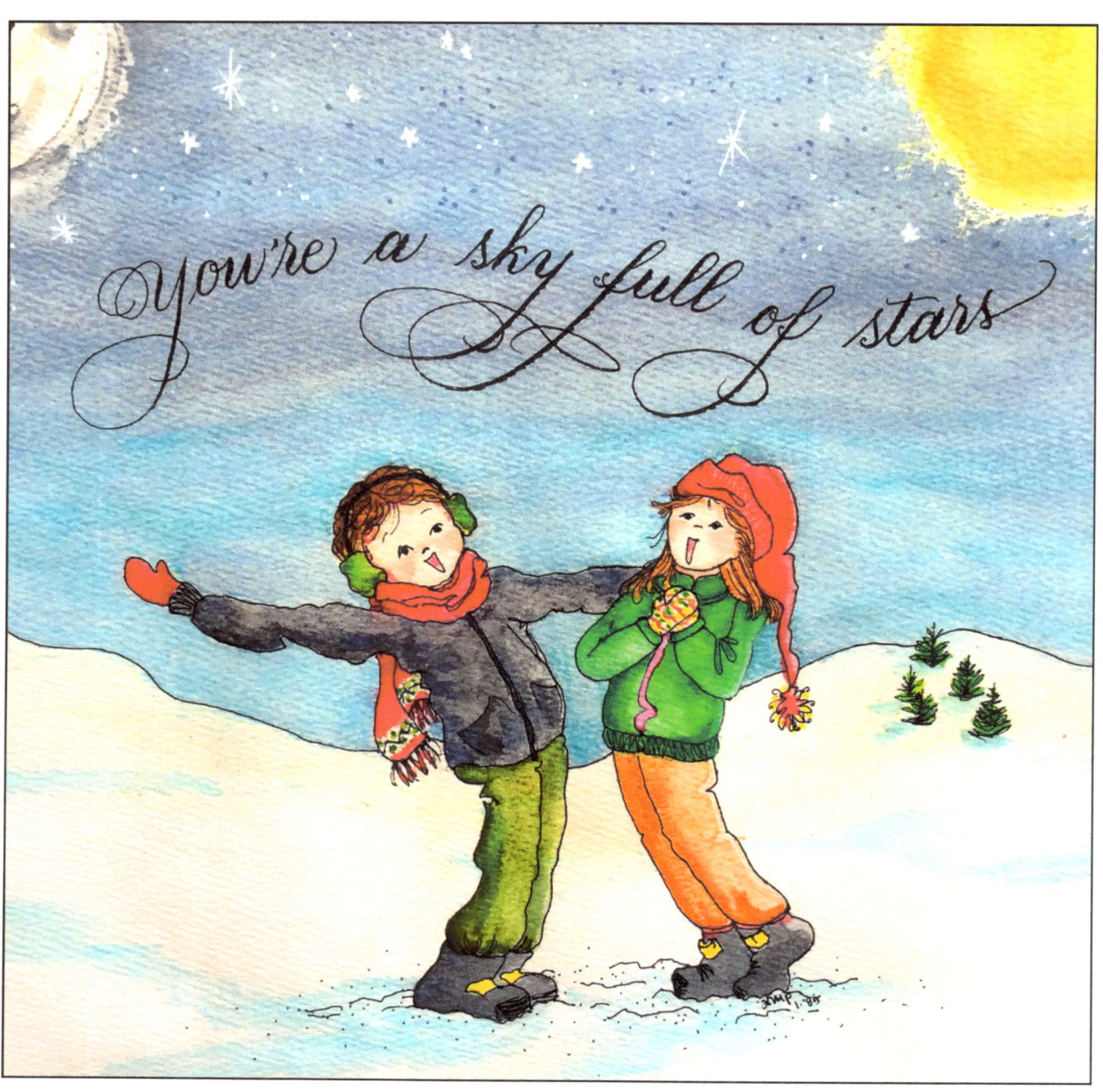

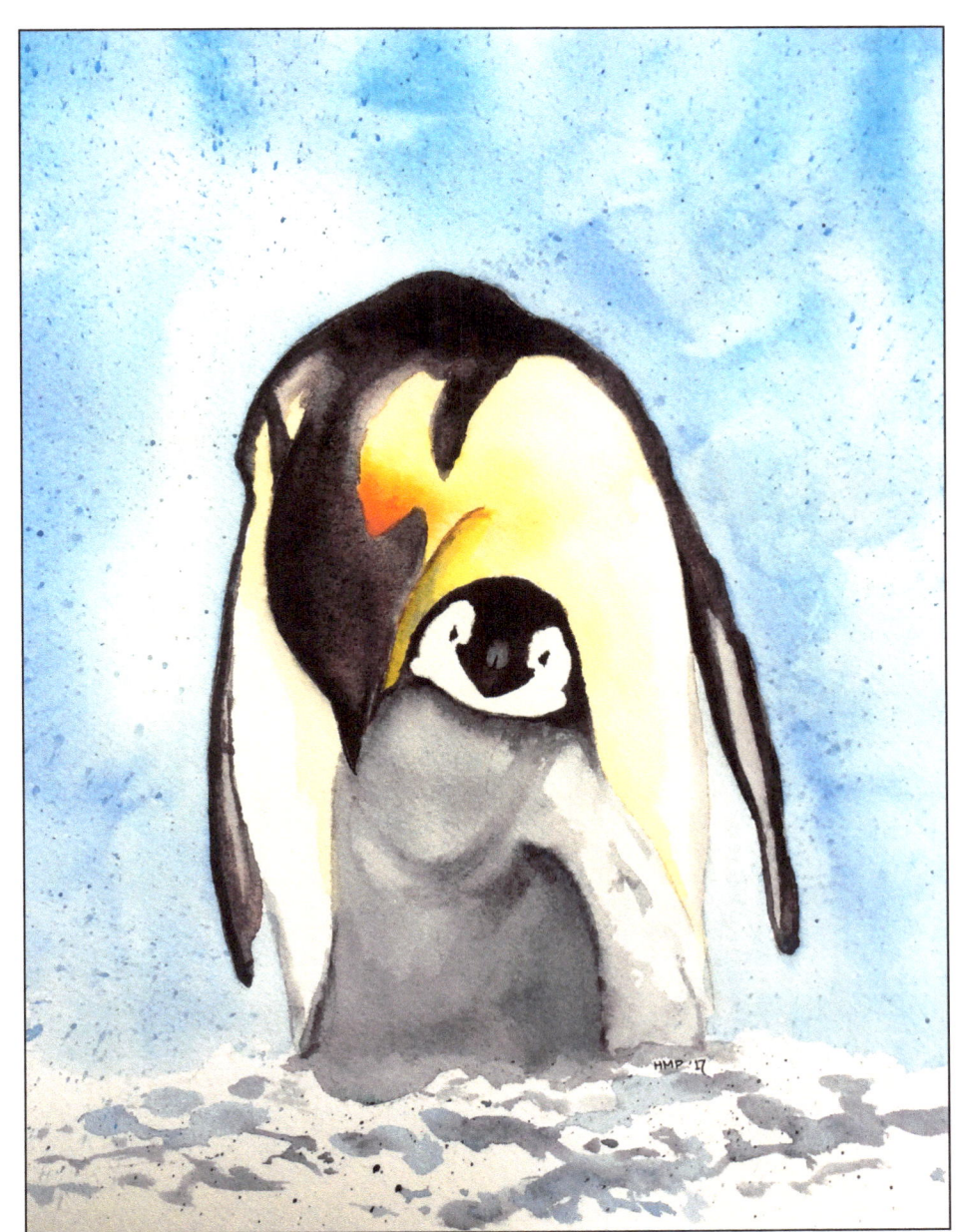

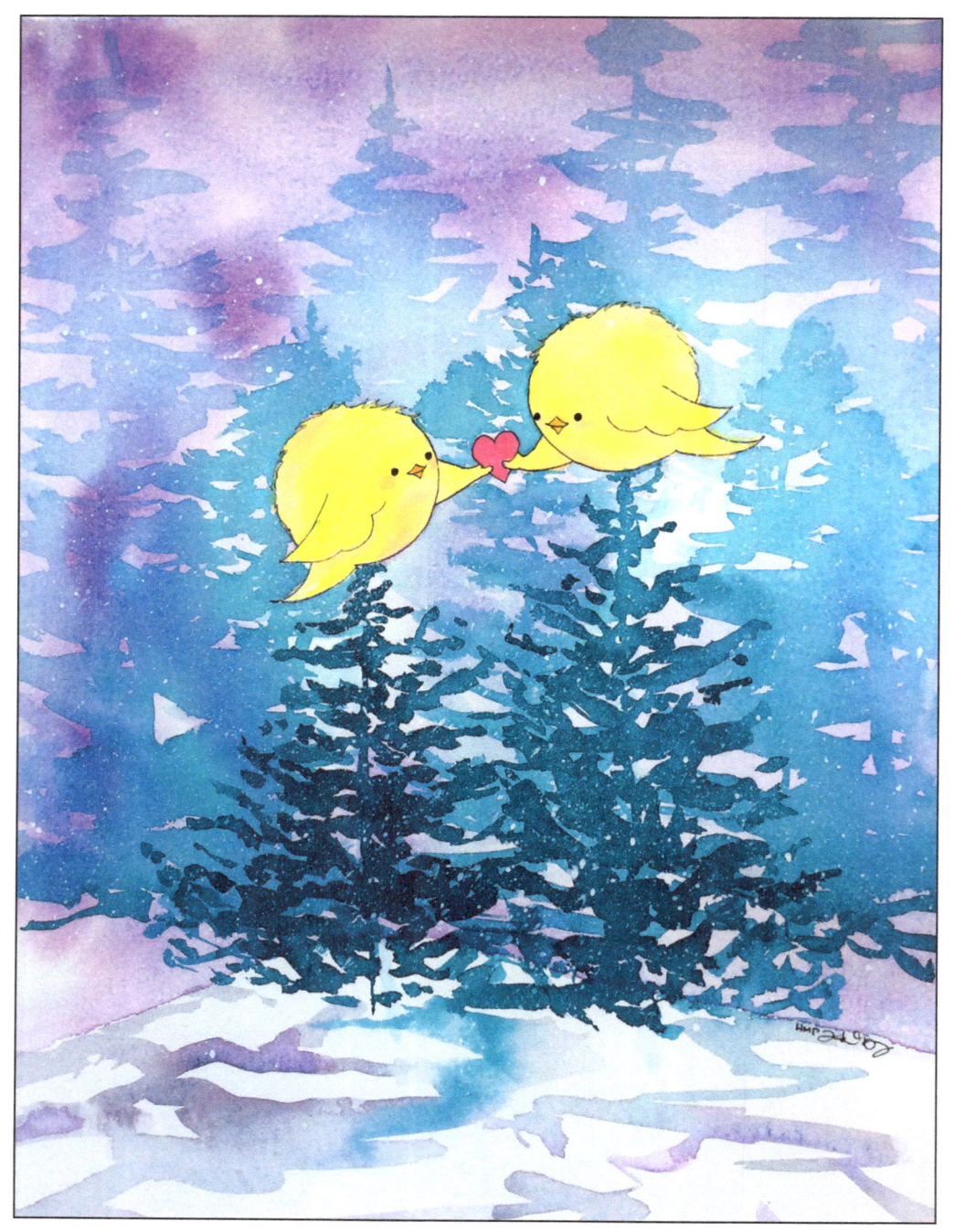

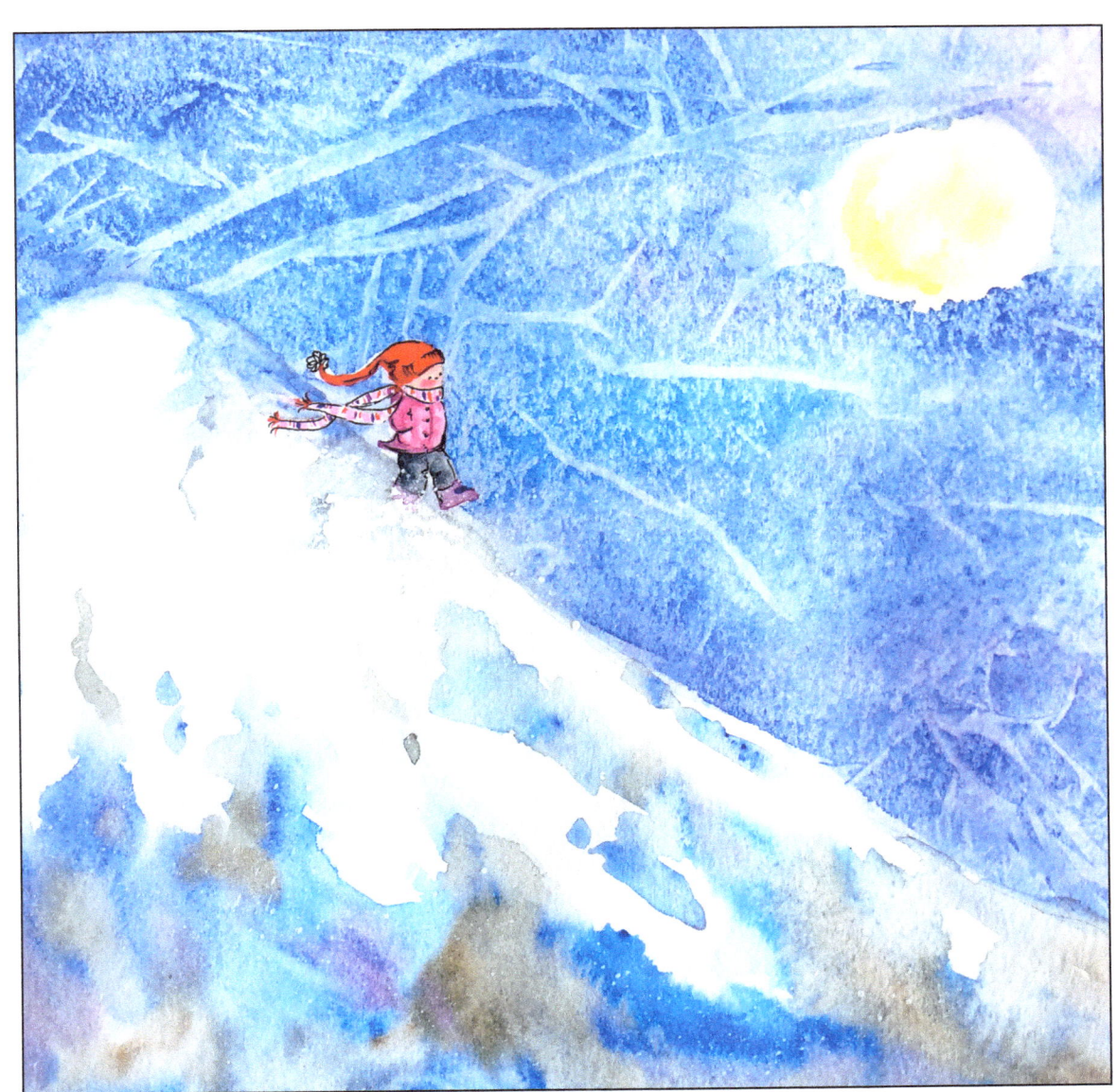

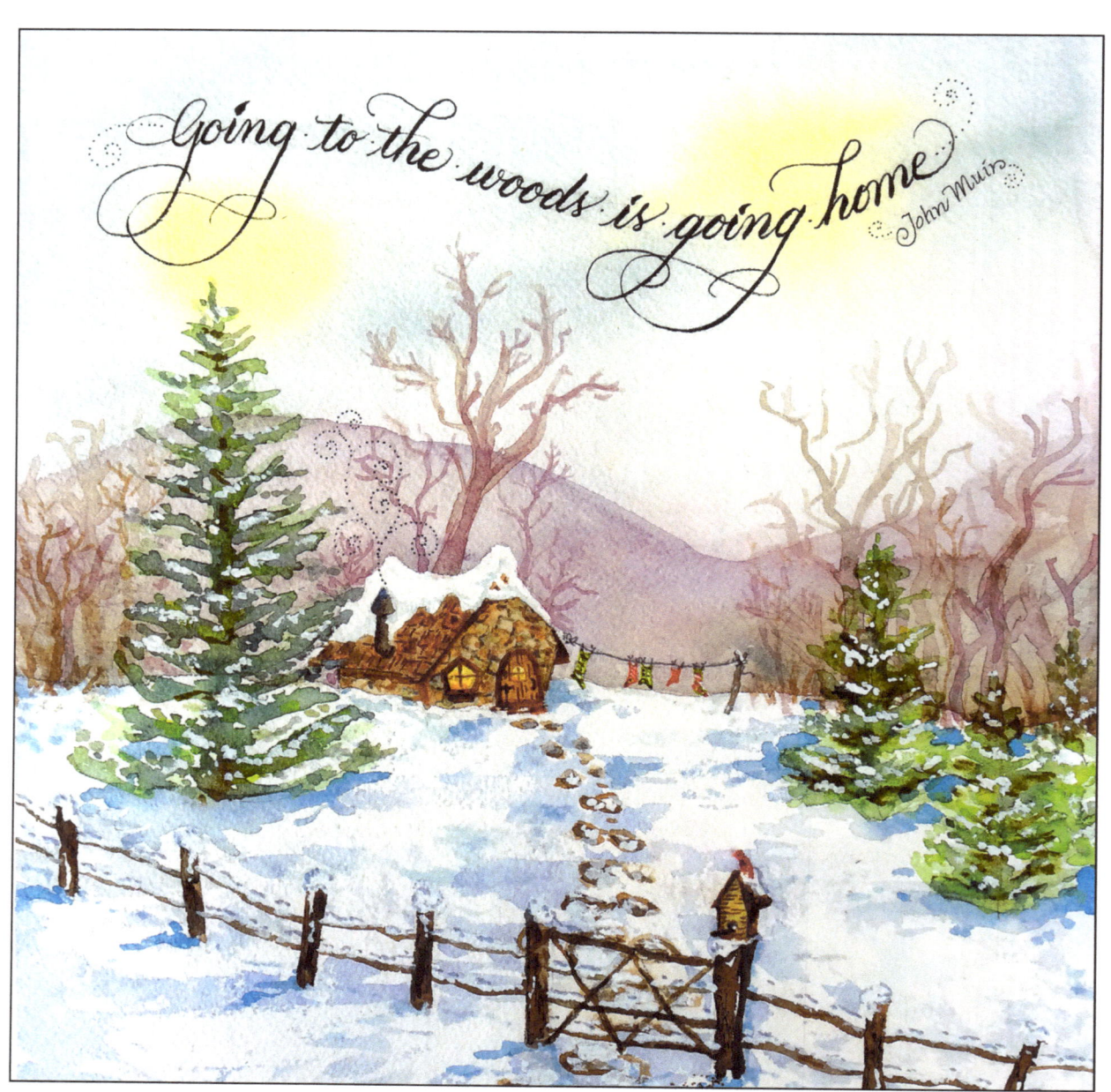

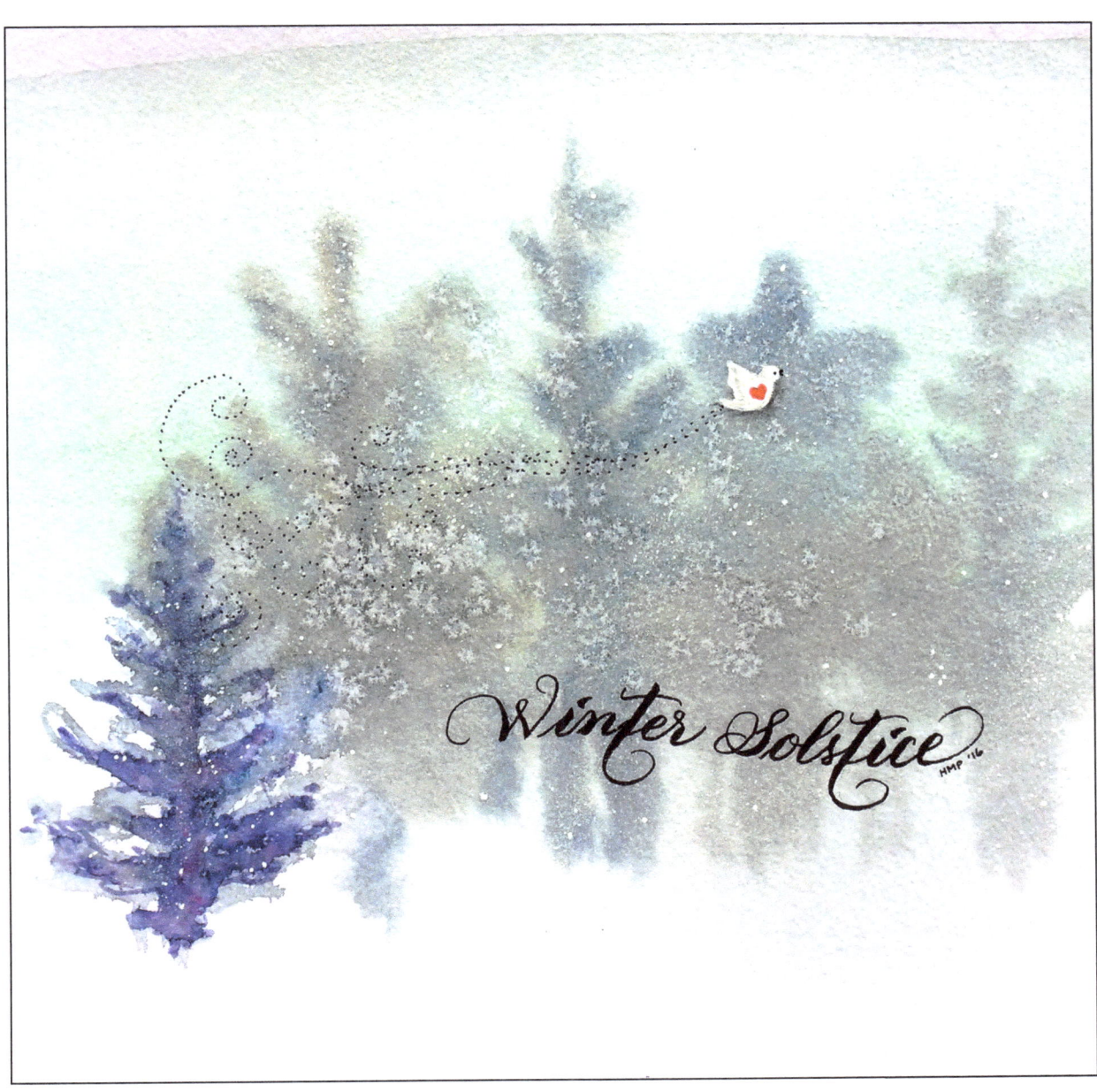

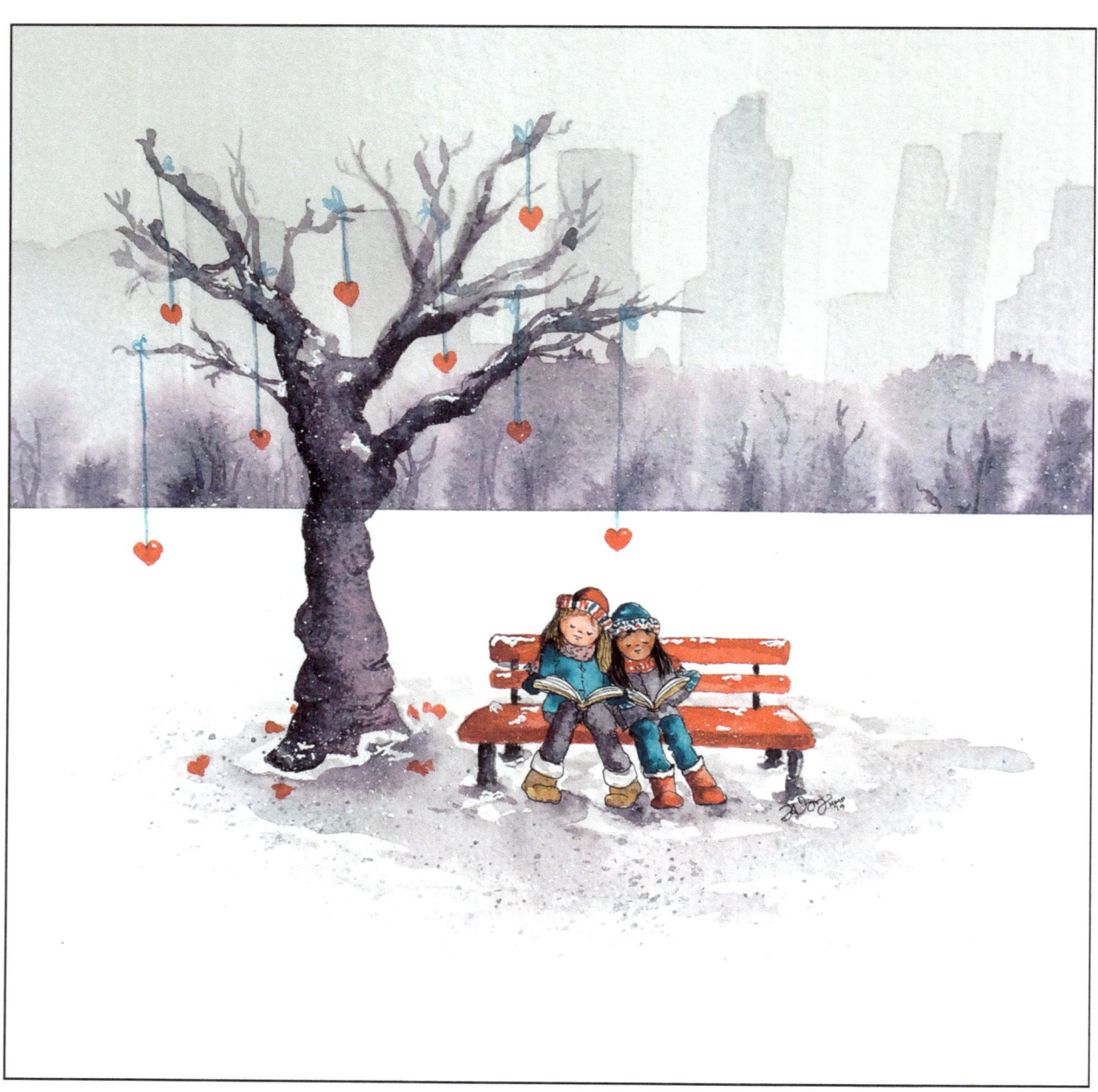

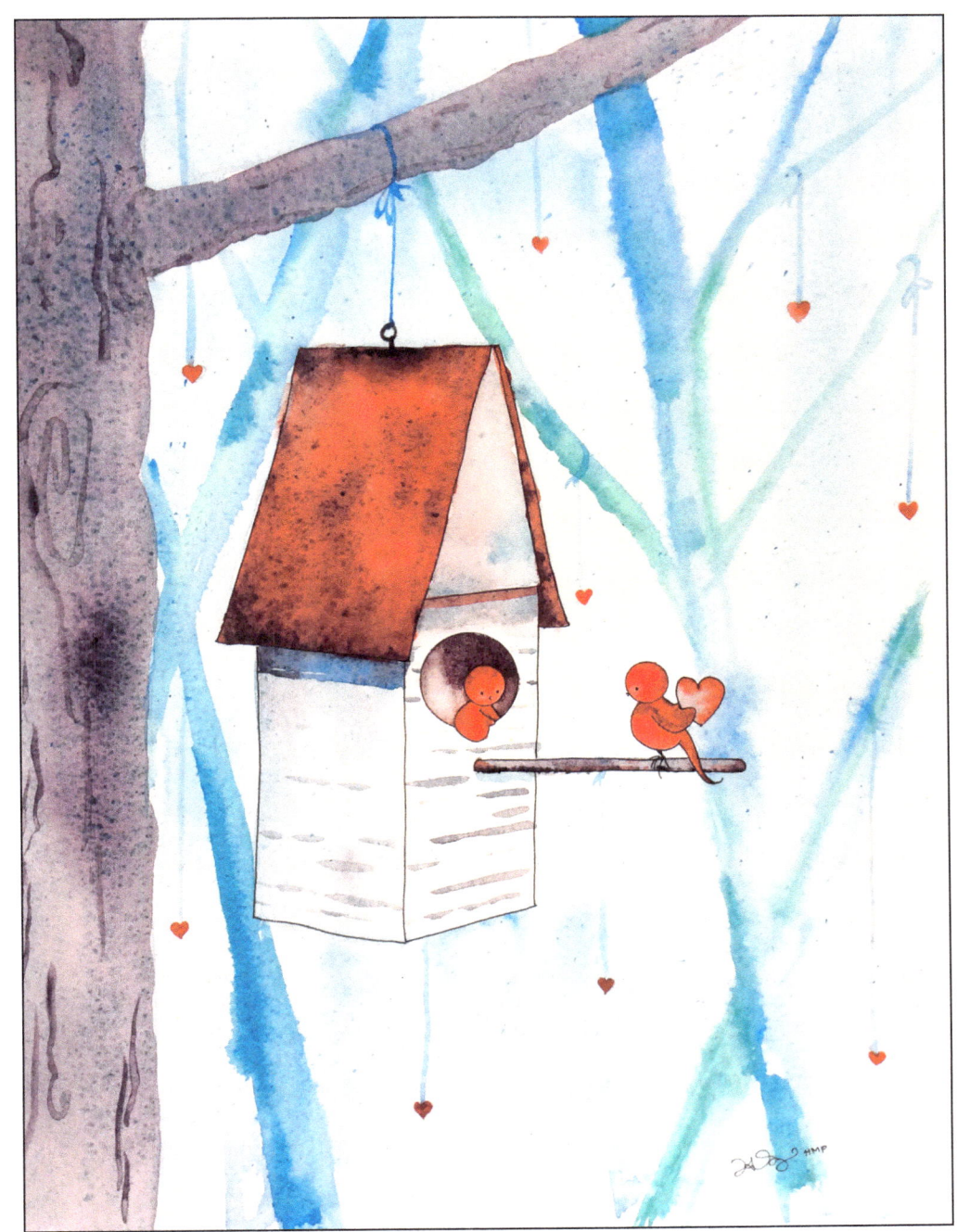

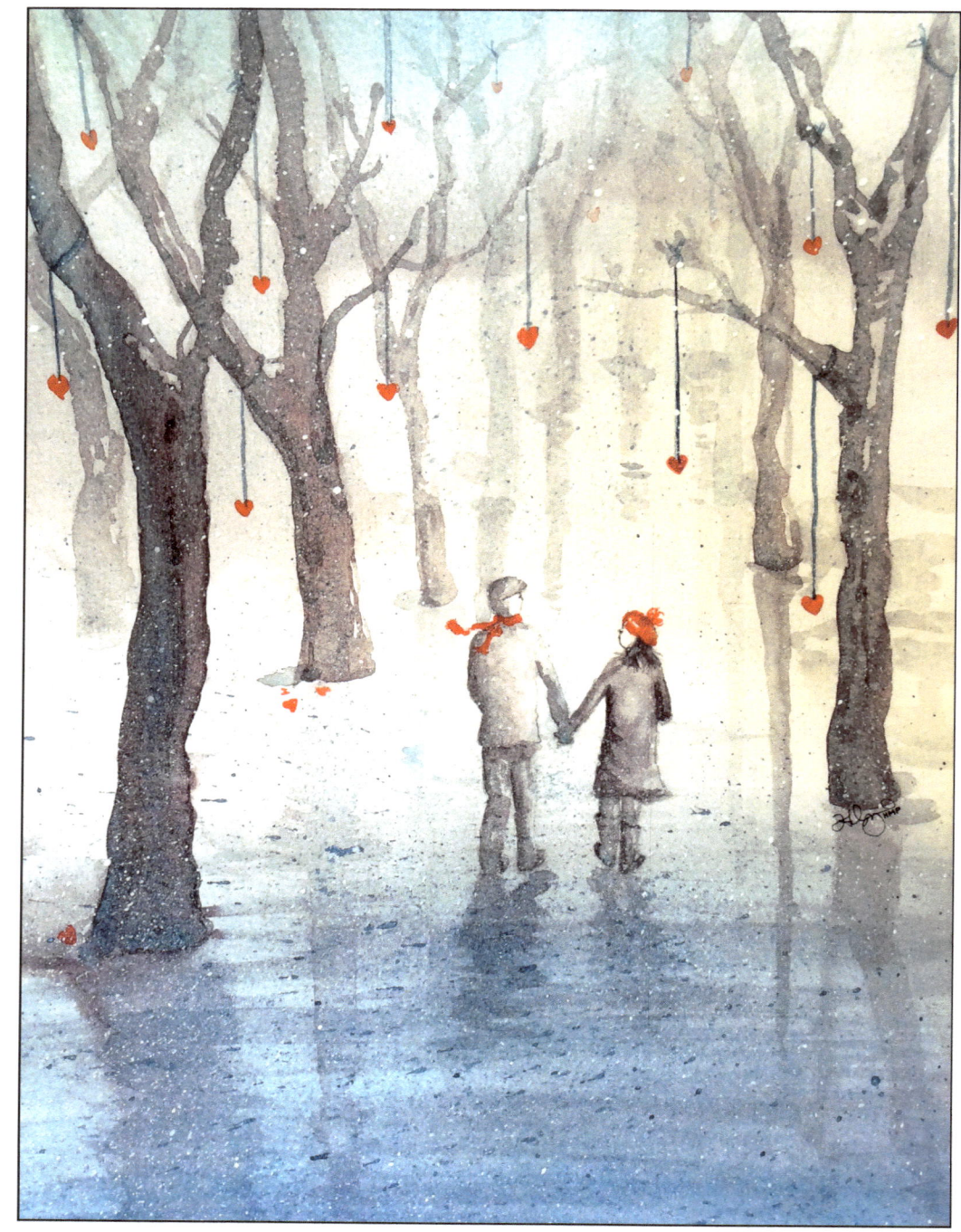

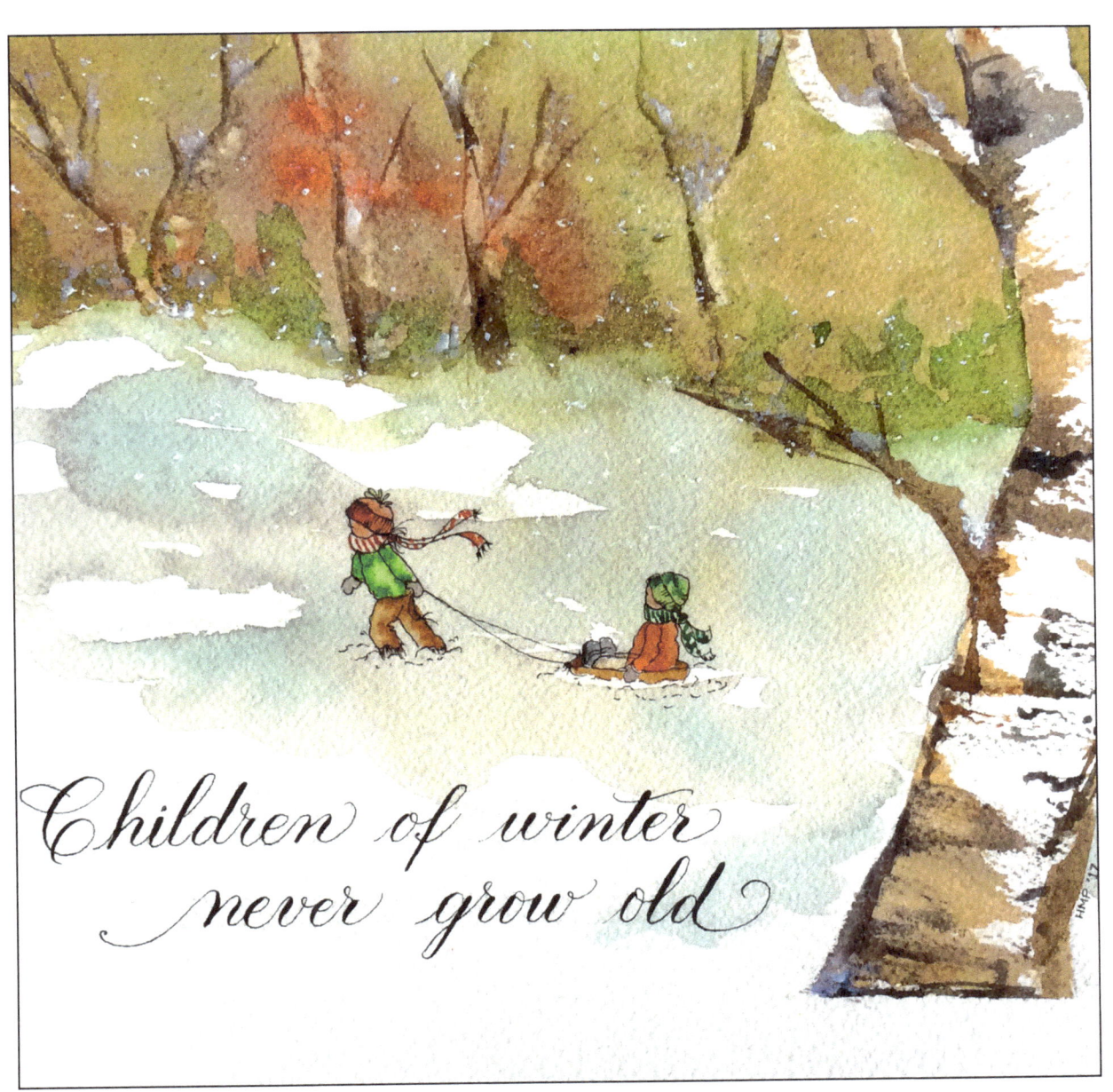

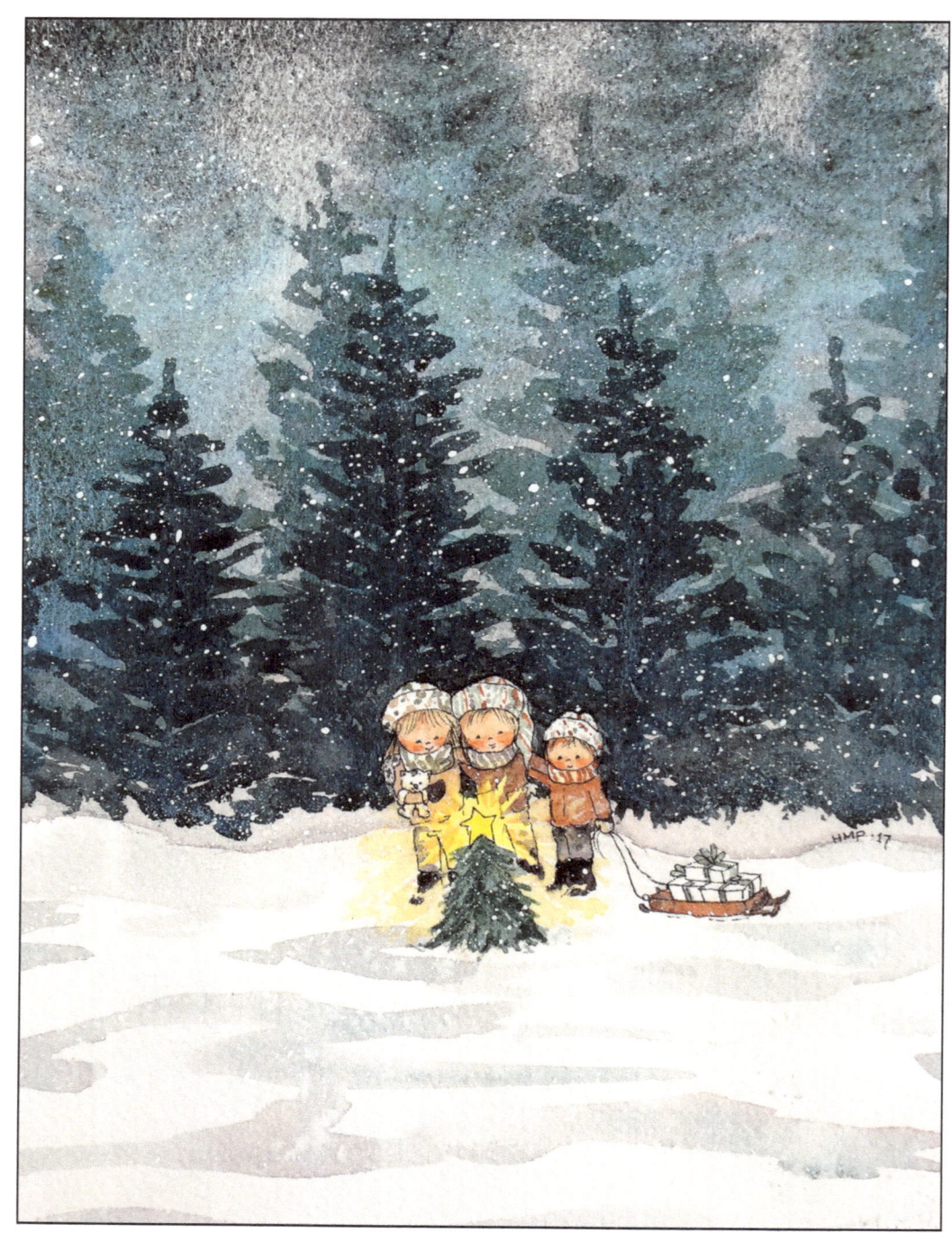

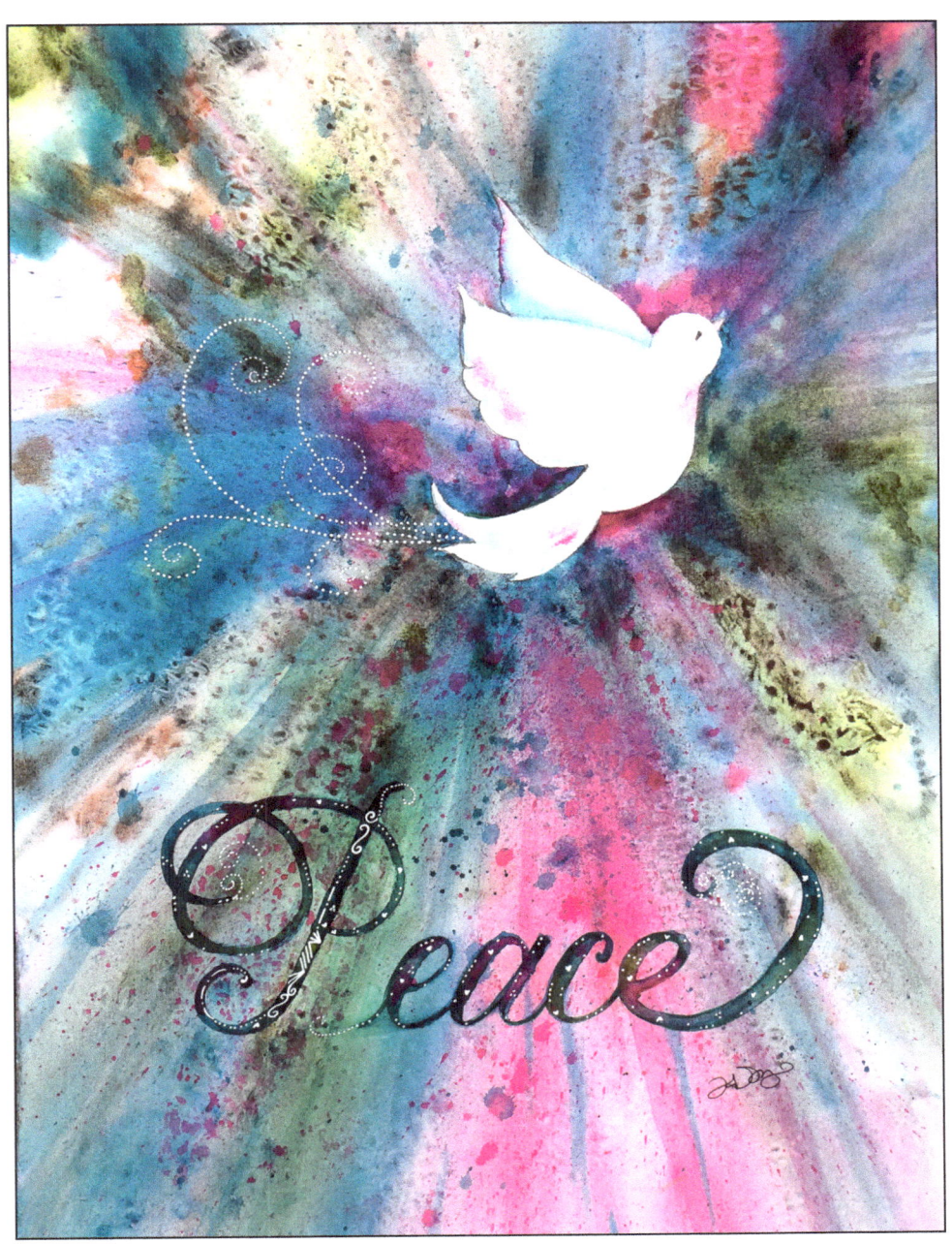

Spring

1) Hush
2) Small Creatures
3) The Little Angel
4) Sweetened with Love
5) Baby Panda
6) Molly
7) Reunion
8) Finding Joy in Unexpected Places
9) The Journey Begins
10) Love on the Line
11) Baby Bunny
12) The Local Library Branch
13) Asher

Summer

1) Rainbow Parrot
2) Tree Frog
3) Sir Seaweed and his Charges
4) Star Catcher
5) Rescuing Joy
6) Moon Dancer
7) Fishing for Love
8) Pondering Panda
9) Charlotte, the Color Collector
10) Seaside Stomp
11) Cosmic Leap
12) Emily's moon
13) Duet

Autumn

1) Stay Wild Moon Child
2) Settled
3) Luminous Bird
4) Baby Hedgehog
5) The Moonlit Library
6) Brandy
7) Chippy
8) Fawn
9) Elephant Walk
10) The Epic of Gilgamesh
11) Sloth Sensibility
12) Baby Owl
13) Peek at Boo

Winter

1) You're a Sky Full of Stars
2) Popples the Penguin with Her Papa
3) Hearts Atwitter
4) Come Walking With Me
5) Cozy Cottage
6) Winter Solstice
7) Keeping Warm
8) Lovebirds
9) Heartcicles
10) Children of Winter
11) Merry Little Christmas
12) Peace

www.ingramcontent.com/pod-product-compliance
Lightning Source LLC
Chambersburg PA
CBHW051048180526
45172CB00002B/559